Duncan Phillips Collects:

Paris between the Wars

ELIZABETH HUTTON TURNER

The Phillips Collection
Washington, D.C.

Published by
The Phillips Collection
1600 21st Street, N.W.
Washington, D.C.

Publication managed and typeset by
Stephen B. Phillips

Designed by Susan Lehmann,
Washington, D.C.

Printed by Garamond-Pridemark
Press, Baltimore, Maryland

Photography of works in The Phillips
Collection by Edward Owen,
Washington, D.C.

Library of Congress Cataloging-in-
Publication Data

Phillips Collection
Duncan Phillips collects :
Paris between the wars / Elizabeth
Hutton Turner
 p. cm.
 Exhibition catalog.
 Includes bibliographical references.
 ISBN 0-943044-16-2
 1. École de Paris—Exhibitions.
 2. Art, French—France—Paris—
 Exhibitions. 3. Art, Modern—20th
 century—France—Paris—Exhibi
 tions. 4. Phillips, Duncan, 1886-
 1966—Art collections—Exhibitions.
 5. Art—Private collections—
 Washington (D.C.)—Exhibitions. I.
 Turner, Elizabeth Hutton, 1952- .
 II. Title.
 N6850.P45 1991 91-30904
 759.4'361'09041074753—dc20 CIP

Cover: Detail, Raoul Dufy, *The Artist's Studio*
(1935) oil on canvas, 46-7/8 x 58-1/4 in.

This exhibition and catalog are made possible through a
generous grant from the **Robert Lehman Foundation**.

Contents

Acknowledgments

Duncan Phillips Collects: Paris between the Wars builds on the efforts of a ten year catalog project and upcoming publication by the research office, whose careful organization and study of Duncan Phillips's manuscripts and papers has made it possible to start analyzing the early history of the Collection. I owe a special debt of thanks to the following catalog researchers: Leslie Furth, Grayson Harris, Lola Jimenez-Blanco, Andrea Vagianos, and Leigh Bullard Weisblat. I also appreciate the many people at The Phillips Collection who have adopted Duncan Phillips's vision of Paris between the wars with such insight, enthusiasm, and hard work. Among those who have helped in special ways are Andrea Barnes, Rebecca Dodson, Joyce Dull, Brion Elliott, Barbara Grupe, Kristin Krathwohl, Laura Lester, Donna McKee, Ignacio Moreno, Stephanie Nealon, José Tain-Alfonso, and Shelly Wischhusen-Treece. I would especially like to thank Karen Schneider for providing bibliographic as well as editorial assistance, Elizabeth Steele for her careful examination and conservation of the works, Cathy Sterling for her tireless and successful funding campaign, and Madame Claude Vaugier for her exhaustive research on the School of Paris. I am also immensely grateful to Joseph Holbach whose negotiations with the Philadelphia Museum of Art were crucial to the in-house presentation of the exhibition, as well as Bill Koberg whose insightful design and installation made the exhibition an effective reality. Above all I am grateful to Elizabeth Chew and Stephen Phillips, as well as our interns Caroline Cassells and Genevieve Wheeler, for their abiding intelligent commentary, effective assistance, and important contributions in all aspects of the project.

I am also grateful to many people and sources for the vintage photographs in this catalog. In France, I am indebted to Gregory Browner of the Man Ray Trust, Francoise Heilbrun of the Musée d'Orsay, Anne Herme of Roger-Viollet, Catherine Schmidt of the Musée National d'Art Moderne, as well as Jeanne Sudour of the Musée Picasso. In the United States, I want to thank Teruko L. Burrell of the J. Paul Getty Museum, as well as Bill Stover of the Carnegie Museum of Art. I could not have done the photo research without the aid of Susan Grant, who helped me on my visit to Paris, and Randi Hunt who eagerly agreed to research several photographic archives on her visit to Paris. Above all I am grateful to authors Billy Klüver and Julie Martin, for their past research and continuing expertise on photographs relating to Paris between the wars, and Merry Foresta, whose knowledge of Man Ray has always been a wellspring for me.

I am also indebted to other individuals outside the museum who have helped make this project a reality. Director Anne d'Harnoncourt, Curator Ann Temkin, and Associate Registrar Nancy S. Quaile of the Philadelphia Museum of Art helped to make the Picasso loan a reality. Director Richard Wattenmaker and Registrar Anita Jones of the Archives of American Art, Smithsonian Institution were vital in helping us with loans from Duncan Phillips's papers. And special recognition goes to Susan Lehmann and Robyn Kennedy, who were patient in listening to our ideas and translating them into a graphic format for the catalog and the exhibition. I also want to thank Dr. Sara Parrott for her perspective on American collectors and for her guidance at a crucial moment in my research.

Finally, I would like to thank Laughlin Phillips and Eliza Rathbone for their unfailing support throughout the preparation of this exhibition.

Elizabeth Hutton Turner
Associate Curator

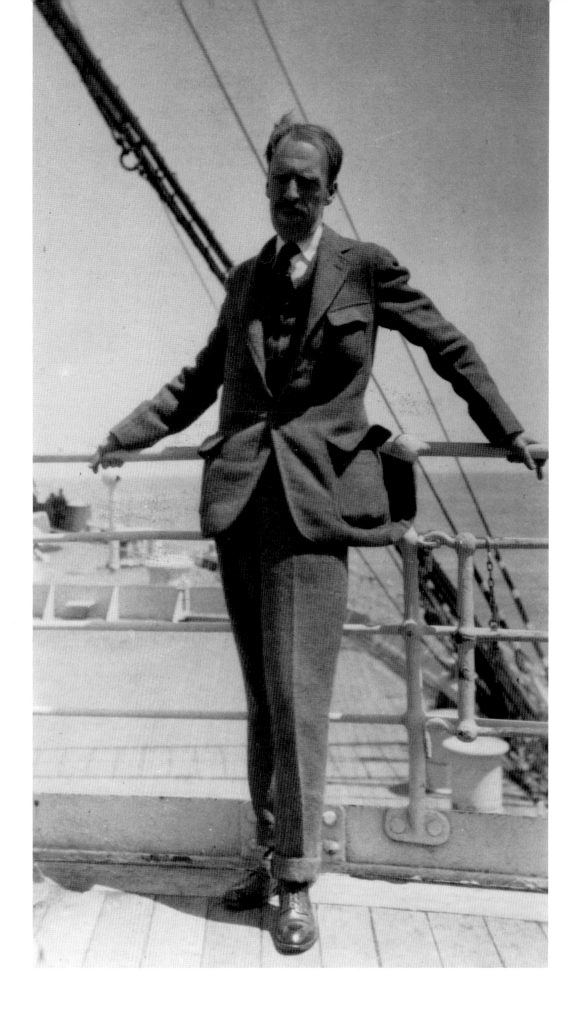

Duncan Phillips Collects:
Paris between the Wars

Introduction

Today it is difficult to imagine The Phillips Collection without paintings by Bonnard, Braque, Dufy, Rouault, and Matisse. Their poetic color and painterly forms are one of the museum's best known aspects—an aesthetic strain which meanders through installations of visually companionable works and suggestive historical correspondences. We have become accustomed to finding Renoir near Bonnard and Matisse, turning the corner from Corot and Cézanne to Braque, and leaving El Greco only to arrive at Rouault or Soutine. Looking back to an earlier moment in our collecting history, however, these artists were noticeably absent as late as 1925, more than eight years after Phillips set out to collect modern art. At that time the lineup in the Main Gallery went from Courbet, Daumier, and Davies to an adjacent wall of El Greco, Kent, Lawson, Ryder, Sloan and Twachtman. In this arrangement we are reminded of Duncan Phillips's earliest and most lasting wish to see the work of living American artists in

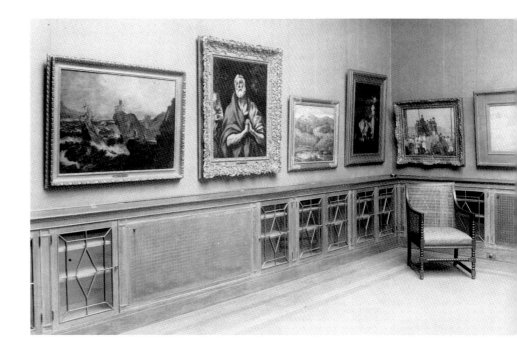

Duncan Phillips, Shipboard on a Trans-Atlantic Voyage (ca. 1920s)

Main Gallery (ca. 1920s)

the presence of and historically accountable to, in his words, "the great rivers of artistic purpose."[1] That this initial, admittedly nationalistic vision for the Collection deliberately omitted Parisian moderns is significant—especially in light of the fact that it would be altered in a feverish span of twelve months. In this, our second exhibition installment of "Duncan Phillips Collects," we will explore the shift in taste which accompanied the arrival and exhibition of painting from "Paris between the Wars."

A Question of Timing

The mid-twenties was arguably late to approach Matisse, Bonnard, Braque and Picasso, each of whom had made their most ground breaking contributions before World War I. Phillips came to Bonnard long after the artist made the sets for playwright Alfred Jarry's profane *Ubu Roi* (1888), to Picasso after the *Demoiselles d'Avignon* (1907) and his great cubist researches with Braque of 1910-1914, and to Matisse after his *Woman with the Hat* and fauve debut at the 1905 Salon D'Automne. Indeed, if given the option to purchase these artists in 1912, the matter of avant-garde art would have seemed a preposterous, irrelevant sideshow•to Duncan Phillips, a young romantic poet and critic traveling in Paris. Smitten by the landscapes of Corot and Giorgione, Phillips was an habitué of the great museums of Paris, not of the contemporary demonstrations at the Salons. He was deeply connected with the past, with aesthetic issues such as the true spirit of impressionism starting with Velázquez.[2] Phillips would not have been found on Saturday evenings at 27 rue de Fleurus, debating the course of radical

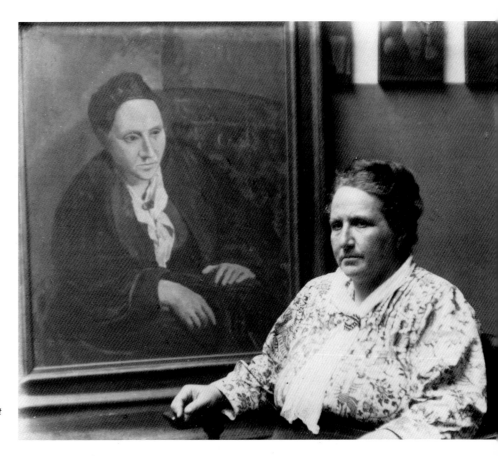

Man Ray, *Gertrude Stein with Picasso's Portrait* (1922) (Courtesy of Man Ray Trust © 1991 ARS NY/ADAGP)

movements at Gertrude Stein's great oak table, in view of Cézanne's *Bathers* (1898-1900) and Picasso's Iberian styled portrait of Stein (1906).

That Phillips approached the French moderns at all required a certain amount of public recanting for past published recriminations. In 1913 when the New York Armory Show brought the Parisian avant-garde literally close to home, Phillips issued a full scale rejection. His "Revolutions and Reactions in Painting" made it clear that Phillips believed avant-garde theories jeopardized "the personal way of seeing and recording vision that constitutes what we mean by the word style." As he then saw it, modern style consisted of three aspects:

the recognition of beauty in modern life, . . . a palette true to the light and darks of the all pervading atmosphere, [and] the mastery of simplification and synthesis. 3

In particular, Phillips singled out Matisse, whom he saw as the leader and supreme theorist of the entire lot, for his "exploitation of the primitive . . . patterns not only crude but deliberately false." When this 1913 essay was reprinted in 1927 as a part of the republication of his 1914 book, *The Enchantment of Art*, Phillips prefaced it with the following remarks:

I feel that I should atone for my own rash expression of blind prejudice against this artist He must be acknowledged as the brilliant descendant of a great Oriental tradition He is one of those rare artists who dare to create an abstract style which corresponds with their crystal-clear mental conceptions and with their exhilarating visual sensations.[4]

The distance between Phillips's "exploitative" and "crude" Matisse of 1913 and his 1927 Matisse, "the brilliant descendant of great Oriental tradition" would be bridged, to a certain degree, by Phillips's increasing appetite for color, his heightened empathy for abstraction, and perhaps most importantly, his growing ability to find stylistic correspondences between contemporary and historical art. This shift of taste would be accomplished independently and at his own pace, certainly not by adherence to fashion—long after the Armory Show had converted John Quinn and Albert Barnes into vanguard collectors. It would be facilitated by Phillips's considered reading and growing acceptance of formalist aesthetic texts such as Clive Bell's *Art* (1913) and *Since Cézanne* (1928) and Roger Fry's *Vision and Design* (1921). More importantly, it would be sustained by the measuring and testing of personal judgment that expectably came with building a collection—a very particular collection, a growing amalgam of modernists housed in an institution of Phillips's own creation—not a private but a public concern, where new purchases could bring highly visible changes in installation and interpretation.

The First Campaign (1918-1926)

Phillips's 1918 decision to establish a small museum in Washington deliberately distanced his concerns from those of the organizers of the large, sensational, freewheeling open or independent exhibitions in New York, which Phillips then believed to be dominated by the politics and excesses of competing "-isms" emanating from Paris: cubism, futurism, and simultaneism. Not only distance but scale was important to Phillips. From the start he saw his museum as "an environment of favorable isolation and intimate contentment,"[5] like Thoreau's Walden Pond or, like his own library. In 1921 he installed and opened his museum at home. This arrangement was made somewhat permanent in 1924 with the establishment of a separate entrance and an elevator leading to a skylit gallery on the second floor. There

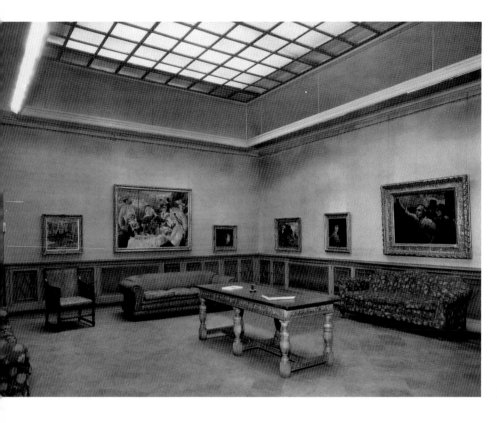

Main Gallery (ca. 1920s)

was no implicit mandate to challenge or to conform to prevailing conventions in such a space. The imprint of something new or modern announced itself gradually through ever changing juxtapositions, ongoing correspondences which would reveal an increasingly familiar conversation of forms. Much like those arriving at Alfred Stieglitz's "291," those coming off the elevator into Phillips's gallery knew when they belonged.[6] Like Stieglitz, Phillips began with (and to an interesting degree maintained) a nineteenth- century romantic's celebration of personal vision, of the artist as one who sees "differently," sees "beautifully," and whose unique images have the power to "enchant." Unlike Stieglitz, however, Phillips made no provisions for unfamiliar bands of abstractionists or their accompanying raucous gawkers. By way of explanation, Phillips often invoked one of his first heros, Courbet, who proclaimed, "There are

no schools or movements worth a moment's attention. There are only true artists and pretenders."[7]

In 1918, keeping in mind the example of Charles Freer's plan for his collection to be housed in a new museum on the Mall, Phillips embraced the possibility (perhaps also the legitimacy) of creating a coherent museum of modernism guided solely by individual taste. To Phillips, establishing a "modern" museum meant broadly creating a public gallery with its main stress on living painters, more specifically American artists. His first buying campaigns in New York in 1918-20 gravitated toward The Eight and their coterie, self-styled modernists, whose expressions, however personal or idiosyncratic, did not completely break with representation, as did their European contemporaries. Phillips was looking for "artists with something to say," in the words of his brother Jim.[8] Among them were Arthur B. Davies and

Ernest Lawson, favorites of his recently deceased father and brother, to whom his Memorial Gallery would be dedicated.

Guided by what he called "Art's two great gifts," the emotions of "recognition" and "escape," Phillips's contemporary collection exercised initially a rather limited aesthetic reach between coloristic fantasy and broadly brushed romantic realism.[9] In Phillips's initial survey, however, color and fantasy predominated. For example, while he tirelessly pursued Maurice Prendergast's color in over twenty-two variations, from *Autumn* (1917-18) to *Snow in April* (ca. 1907), Phillips contented himself with only two of John Sloan's New York vistas. Finding what he believed the essential match between color and form in the sweeping blue arc of the Third Avenue El in *Six O'Clock* (1912) and the misty, tilting, open center in *Wake of the Ferry* (1907), Phillips must have connected these paintings with his early love of Japanese color prints and his interest in Degas.

By the mid-1920s Phillips increasingly accommodated the cool colors and streamlined forms of newer American realism, as in Guy Pène du Bois' stylish *Arrivals* (1918-19) and Rockwell Kent's luminous *Mountain Lake* (1922-25). These he saw as a counterpoint to the freer, imaginative landscape improvisations by John Marin and Arthur Dove from Stieglitz's modernist circle. By 1924 Phillips made provisions for the tide of new or emerging art in a second floor room called "The Little Gallery," which served as a kind of tentative staging area adjacent to the clearer, more fixed conclusions presented in the original, larger "Main Gallery."

Phillips's ambition for the Main Gallery was seemingly boundless. He spoke boldly of the works hung there as his "American Prado."[10] Just as this great Spanish institution had permitted Manet to tap the modern spirits of Goya, Velázquez and El Greco, Phillips wanted to provide

Duncan Phillips in France (ca. 1920s)

American artists with a similar historical reach and proving ground. Early on Phillips engaged in "rather exciting negotiations with foreign dealers"[11] to secure certain aesthetic milestones such as El Greco's *The Repentant Peter* (ca. 1600), Chardin's *A Bowl of Plums* (ca. 1728), and Daumier's *Three Lawyers*. In December 1922 the New York display of the private collection of impressionist impresario Paul Durand-Ruel held particularly great collecting possibilities. This event led Phillips into hushed negotiations for a masterwork which required his presence in Paris the following year.

Paris

In 1923 Phillips took the transatlantic ocean liner to Paris, like so many young intellectuals of the post-war or "lost" generation. Yet, unlike these contemporaries Phillips would not use the transatlantic as means of seeking a new artistic direction. To the contrary, Phillips avoided that mind-set as if heeding T. S. Eliot's words of advice to the young writer Robert McAlmon in 1921:

I'm glad to hear that you like Paris; the right way of course is to take it as a place and a tradition, rather than as congeries of people who are mostly futile and timewasting, except when you want to pass an evening agreeably in a cafe.[12]

Like an archaeologist on a dig, Phillips aimed to retrieve from the rubble of war-torn France paintings by nineteenth-century pioneers—not the much discussed Cézanne, but artists such as Daumier, Corot and Renoir—those whom he believed to have been forgotten, or if not forgotten then abused and neglected by contemporary Parisian radicals.

Phillips arrived in June at the height of the tourist season and soon after fled the noise and bustle of the city with his wife, Marjorie, a plein air painter, and their eleven month old

baby. The couple settled in Versailles and contented themselves with day trips to the city. Dressed in colorful tweeds, sporting a cane, Phillips looked like a stylish Jamesian character on the grand tour along the boulevards. Marjorie Phillips recalled how one day in the Tuileries Duncan caught the eye of "black cloaked Latin Quarter types" who hailed her husband as "Son Britannic Majesty!"[13]

Indeed, the Phillipses took no turn which may have led them into bohemia. They were not drawn to the intersection of the Boulevards Raspail and Montparnasse, the great hub anchored on two corners by the Café Dome and the Café Rotunde, a well-known gathering spot for the students of Matisse before the war. There would be no stop down the street on 22 rue Campagne Première at Man Ray's photo studio and erstwhile gallery, an option explored by Ernest

Hemingway and Ezra Pound, as well as art patrons John and Elinor Nef, then just building a collection which would include the latest works by Pascin and Derain. One of the last dada evenings in Paris, "La Soirée du Coeur à Barbe" featuring Man Ray's film debut and well-publicized departure from the sticky medium of paint, "Retour à la Raison," came and went that July without their notice. (Had he seen it, Phillips most likely would have agreed with New York Sun critic Henry McBride's skeptical review.)

The Phillipses spent time on the Right Bank, not the Left, drawing near the hub of the newly burgeoning post-war international art market. Here in the small art quarter near the central leisure and business districts of Paris, the legendary Gerald and Sara Murphy had their epiphany about Picasso at Paul Rosenberg's gallery on

View of the the Boulevard Montparnasse and the Boulevard Raspail (Courtesy of the Collection of Billy Klüver and Julie Martin)

Man Ray, *Juan Gris* (1922) (Courtesy of the Collection of the J. Paul Getty Museum, Malibu, California; Man Ray Trust © 1991 ARS NY/ADAGP)

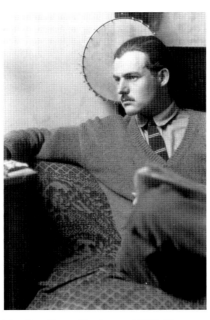

Man Ray, *Ernest Hemingway* (1923) (Courtesy of Man Ray Trust © 1991 ARS NY/ADAGP)

the rue de la Boëtie. At nearby Paul Guillaume's, the notorious American patron Albert Barnes "discovered" and purchased all the works by Soutine in 1923. Much like John Quinn, who also traveled the rue de la Boëtie in 1923, Phillips was searching with the idea of a modern masterwork in mind. Both chose to make inroads with well-established dealers. Quinn found his masterwork in the private stores of Felix Fénéon, early champion of Seurat and Signac and at that time contemporary curator of Bernheim Jeune Gallery. Phillips found his in the well-appointed apartments of Joseph Durand-Ruel, son of the impressionists' champion.[14]

Forty years later, Marjorie Phillips still remembered the occasion quite

Man Ray's Studio, 22 Rue Campagne Première (Courtesy of Man Ray Trust © 1991 ARS NY/ADAGP)

well. It was a lunch at which she and Duncan were seated directly across the room from Renoir's *Le Déjeuner des Canotiers (The Luncheon of the Boating Party)*. Other details, however, such as the fashion, deportment or conversation of their companions seemed to have faded in the light of that unimpeded view of Renoir's life-size nineteenth-century revellers. What she saw was "entrancing, utterly alive and beguiling." Face to face with the culmination of Renoir's impressionism, a masterful marriage between figuration and the great caprice of light and color, the young American couple became so transfixed that the question of its purchase was not "if" but "how much?."[15]

By mid-July the Phillipses had sealed the agreement which would bring the painting to Washington in October. They did not flinch at the record price of $125,000. As Marjorie recalled, Duncan considered it a worthy trade for what would be a "cornerstone" of the museum. (In truth, he had far exceeded his acquisitions account, and would do so for the next two years in order to pay for the Renoir.) Writing to museum treasurer Dwight Clark in July 1923, there was not a hint of hesitation as Phillips explained enthusiastically that what would be coming their way was:

one of the greatest paintings in the world, . . . finer than any Rubens, . . . as fine as any Titian or Giorgione. [It] will put us on the map as a collection of modern art second to none anywhere![16]

With the announcement of this purchase in the fall of 1923 there came, as predicted, newspaper headlines and immediate prestige. Yet, the abiding presence of the painting in the Main Gallery was to have even far greater aesthetic consequences for Phillips. For though he had a full understanding of Renoir's "renaissances"—Renoir as the "modern Titian," or "new Veronese"—Phillips little suspected that Renoir, the good grey genie of the nineteenth century, "the colorist who cannot rest from color,"[17] also would put him on a veritable collision course with the very French radicals he had most sought to avoid. Phillips, like most Americans in the early twenties, had no hint of the shifting ambitions of the pre-war avant-garde.

A Changed Paris

Gertrude Stein could have warned Phillips, as she did anyone who came to call: the revolution was over. After the war, it was, in her words, a "changed Paris." "The old crowd had disappeared," split up in their separate ways. By way of illustration, she liked to recall how one evening after the war, Man Ray brought his latest photo of Picasso and passed it among her guests. When it came to Braque, the painter commented, "I ought to know who that gentleman is," a reference to the fact that he and his fellow comrade in cubism now rarely met.[18]

In 1914 the great cataclysm of war had indeed disrupted the avant-garde, sent them away from Paris or left them on their own to establish new priorities which were only beginning to surface in 1916. The year 1916 found Matisse, in his words, "not in the trenches" but in the "front line of his own making," abandoning pure color and wrestling with the verities of pictorial space in his Quai St. Michel overlook.[19] In 1916 Raymond Duchamp-Villon returned from the front to enlist cubism in the service of a patriotic theme. This came in the form of an emblematic *Gallic Cock* (1916) crowing at the post-war dawn of New France.[20] The critic Apollinaire, a veritable weathercock of change himself, praised the 1916 exhibition of former fauve André Derain for his solid forms, his clear definitions and his passionate study of "the great masters." Referring broadly to a "French School" built upon "the daring innovations of French painters throughout the

14

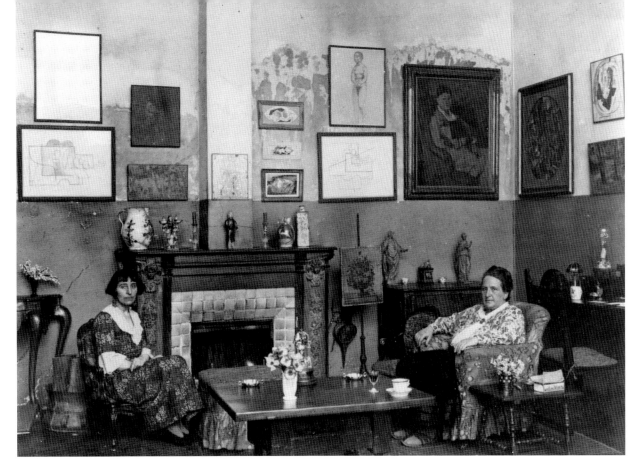

Man Ray, *Gertrude Stein and Alice B. Toklas at Home* (1922) (Courtesy of Collection of the J. Paul Getty Museum, Malibu, California; Man Ray Trust © 1991 ARS NY/ADAGP)

Man Ray, *Picasso in His Studio* (1922) (Courtesy of Man Ray Trust © 1991 ARS NY/ADAGP)

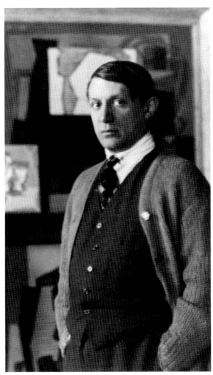

nineteenth century," Apollinaire exhorted his compatriots, like Derain, "to go beyond the most audacious experiments of contemporary art in order to rediscover the simplicity and freshness of the first principles of art."[21]

In 1917, as if addressing Apollinaire's new charge, the war-wounded but convalescing Braque returned to his studio and began again by making notes about classicism, not cubism. He wrote, "the pre-classic style is a style of rupture; the classic style is a style of development."[22] Returning to the heros of his father and his father's father, Braque loosened his forms, openly explored the texture of brushed surfaces and began to embrace the painterly forms of Corot. In 1917, Picasso returned to Paris from Rome with his own unexpected set of appropriations. Most notable was a series of Ingres-like portrait drawings comprising a rogues' gallery of patron saints—Erik

Satie as well as Renoir, who had himself studied Ingres in his later years. In 1916 and 1917 Matisse and Bonnard traveled south on separate occasions to seek out Renoir, then a fragile octogenarian in Cagnes, as if to lay claim to the old man's under-standing of Mediterranean light—that elusive unifying luminism which would later dominate their pictures.

In a "changed Paris," looking at the past became the prescription for choosing a future direction called classicism. Classicism in this context did not signify a particular style but inferred a kind of serious or mature intent clearly separate from avant-garde antics. In 1919 the cubist Juan Gris wrote his dealer D. H. Kahnweiler:

The exaggerations of the Dada movement and of others like Picabia make us look classical though I can't say I mind about that.[23]

Post-war classicism pulled the artist away from the abrupt, jarring lan-

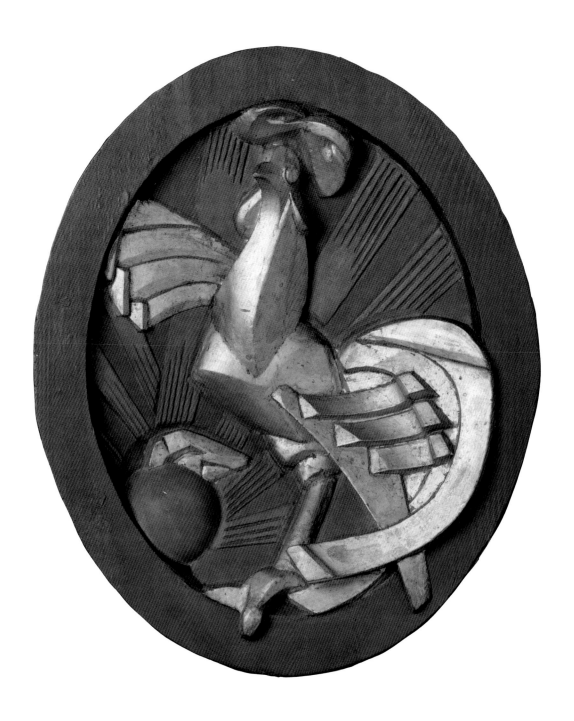

Raymond Duchamp-Villon, *Gallic Cock* (1916) polychrome plaster relief on wood support, 17-1/2 x 14-3/4 x 2-3/4 in.

guage of revolution and asked him to resolve his differences with the art of the museums.[24] Gris rightly compared this kind of classicism to stylistic atavism. For it resided solely in the artist's ability to conjure and convincingly revitalize forms from a remote or made-up ancestry—a memory of grandiloquence, measure, balance and judgment. As Gris concluded in 1921, "Well, now I believe that the quality of an artist derives from the quantity of the past that he carries in him."[25] Perhaps not for the brilliant analytical Gris, but for others, such as Phillips's later favorites, Bonnard and Braque, this new "classical" legacy portended a remarkable renaissance.

16

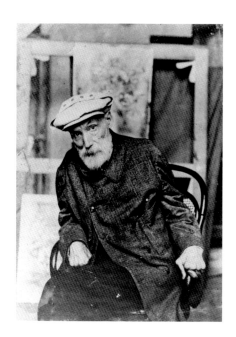

Renoir at the end of his life, photograph owned by Picasso (Courtesy of Archives Picasso)

"A True Descendant" of Renoir

The Luncheon of the Boating Party had occupied the west wall of Phillips's Main Gallery for almost two years before he would discover, in his words, "a true descendant of the sensuous Renoir."[26] It was a painting which stood out "like a jewel" at the 1925 Carnegie International Exhibition in Pittsburgh. As early as the fall of 1923 Phillips's dealers Paul Rosenberg and Walter Fearon showed him examples of the "new Matisse"[27] and the "classic Picasso."[28] Even though this beckoned Phillips to look in the direction of contemporary French painting, he was content to survey what he suspected was the the latest French fashion away from the New York art market, at the annual exhibition in Pittsburgh. Here indeed a contemporary French painting struck him like a revelation, though it was not the one anticipated by Phillips's dealers.

A new painting by Pierre Bonnard captured him. This was not an especially pretentious painting. It was not large or animated like the Renoir and perhaps warranted closer comparison with Matisse's portraits from the same year. Nevertheless Phillips knew what he wanted. The cable to the director read:

PLEASE RESERVE 'WOMAN WITH DOG' BY BONNARD IN YOUR PRESENT EXHIBITION. I HAVE COMMUNICATED DIRECTLY WITH PARIS AGENT ABOUT THE PICTURE. WILL WRITE WHEN I HEAR FROM BERNHEIM.[29]

He wanted it on hold, and he wanted it as soon as possible. Approximately twelve fast exchanges later, Phillips had gained special consent from the Bernheim Jeune Gallery and the Carnegie to pull it from the tour. It seems clear that Phillips's appreciation was immediate. Never had he seen such a combination of ecstatic and evanescent color in a twentieth-century work. He wanted its effect to register accordingly in his collection.

This particular composition is tall and rather elongated, tall like the posture of the seated young woman, long like the striped wall immediately behind. The young woman sits in the soft half-light of an afternoon tea

Bonnard with members of the Carnegie Prize Jury at Pittsburgh in 1926 (Courtesy of The Carnegie Museum of Art, Pittsburgh)

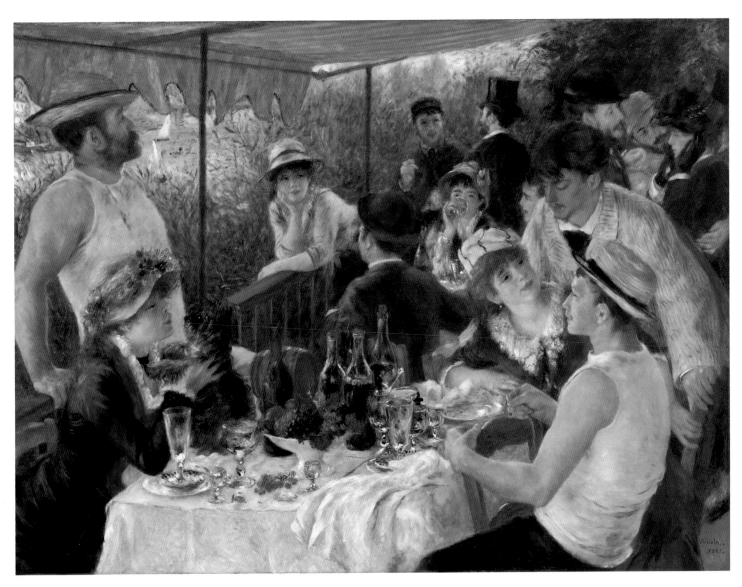

Pierre Auguste Renoir, *The Luncheon of the Boating Party* (1881) Oil on canvas, 51 x 68 in.

Pierre Bonnard, *Woman with Dog* (1922) oil on canvas, 27-1/4 x 15-1/2 in.

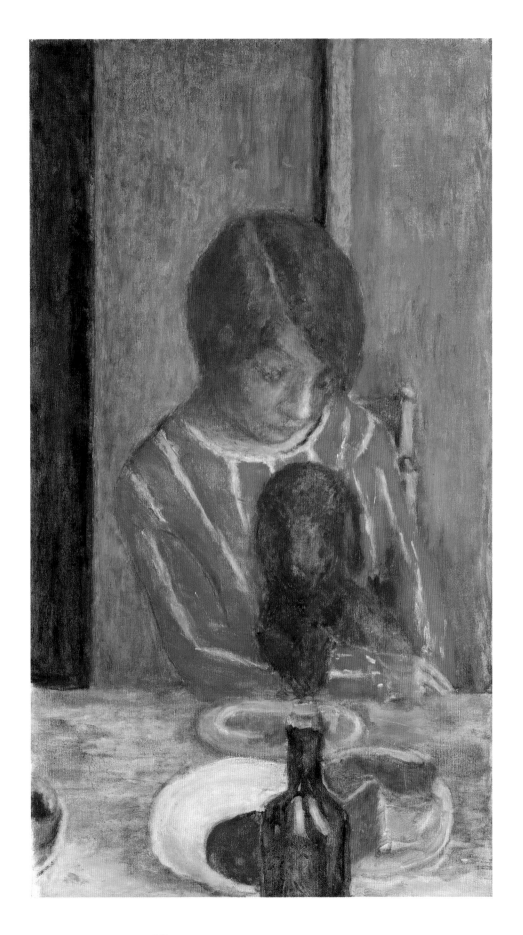

table. She, along with the last morsels of the meal, occupies the absolute center of our gaze though her attention is diverted by the little red dog in her lap. The tilted, rather telescopic perspective is reminiscent of Japanese prints or, more in keeping with Bonnard's inclinations, like the fragmentary view of a movie still, only the action or narrative eludes us. As if daydreaming, we are left to ponder the grey-blue-green of the wall that meets the blue contour of the fauve red dress. We linger over the opalescent medley of three plates spread on the white-blue-violet cloth.

Something in Bonnard's hypnotic commingling of figuration and color took Phillips back to Renoir. Perhaps, he found the shadow of Renoir's beloved Aline and her tousled pup in Bonnard's rendering of his companion Marthe and her pet. Perhaps Phillips recognized another luncheon theme in Bonnard's meal. Soon after the purchase, Phillips wrote about Bonnard's and Renoir's "shared genius for color." As Phillips surmised:

What he has done is to carry his observations of the evanescent, especially of the movements and comminglements of color in light and shade to hitherto undreamed subtleties of suggestion. He is a true descendant of the sensuous Renoir, but more sophisticated, less robust and normal.[30]

The coincidence of Bonnard's postwar rebirth as an impressionist and Phillips's maturing formalism unlocked a new aesthetic door for the Collection. Bonnard's color—his seductive high-keyed distortions and transformations, his luscious vermillion and violet which are so different from Renoir but equally "alive" or inventive—drew Phillips like a moth to a flame. He identified this new color both with the historical purposes present in his Main Gallery and with the new formal challenges of modernism. Its iridescent, atmospheric surfaces hugged the edges of both representation and abstraction. It enveloped and celebrated everyday modern life, then, spreading like an opalescent stream, it liberated the artist's inner vision. Arriving at this understanding, Phillips did not turn his back on Bonnard's contemporaries. Bonnard's visit to the museum in 1926 and his firsthand response to paintings in the Collection, must have added to Phillips's momentum for new color. As Marjorie Phillips later recalled, Bonnard "stuck especially to canvases close to his own way of seeing."[31] Within a year, almost certainly with Matisse's new Persian arabesques in mind, Phillips would soon write that Bonnard

prepared the mind of the twentieth century for even greater freedom of sensation than the impressionists had made possible and announced the coming of influences no longer Greek but Oriental.[32]

A Second Campaign

With the 1926 publication of *A Collection in the Making*, Phillips effectively chronicled the initial phase of his collecting history and announced the beginning of another. This second campaign began with a pronouncement to would-be reviewers. As he wrote to critic Elizabeth Luther Cary:

I would be sure that you would understand what I am trying to do, namely, exploring the whole field of modern painting in preparation to making a choice of what is best in each field The next edition will, no doubt reveal marked changes. There will be significant eliminations, even more significant specializations, according to my developing taste and maturing convictions [postscript] The exploration I speak of is not complete as the French moderns now living should be studied and represented.[33]

Phillips must have been certain of the importance of this moment in French painting, for this new exploration would cost him dearly on two fronts. In the rapidly heating isolationist climate of the late twenties, such a shift toward French moderns would be interpreted as an act of disloyalty to American art. As if in anticipation, Phillips told Cary:

I know I will be accused of carrying water on both shoulders, to which I can only answer with, 'would that I had more than two shoulders to give to art.'[34]

In fact, Phillips's purchases continued to favor Americans four to one, but entering the bullish French contemporary art market at this point would almost certainly tip the monetary scales towards Paris. Indeed, much of this new exploration would be accomplished with extremely limited capital, buying and exhibiting first and paying or trading later.

Yet another factor in this second campaign was Phillips's growing confidence and ambition—ambition not only with respect to the Collection's quality and depth, but also to its visibility and influence in New York in 1927. As of yet, no American museum had undertaken such an assessment of post-war painting in Paris. Certainly none in New York, since no museum of contemporary art yet existed, though Albert E. Gallatin, collector, painter and a former colleague of Phillips from the 1918 Allied War Salon, had plans underway for the fall of 1927. Starting in late 1926, Phillips was well-positioned, both through his publishing contacts and his contacts with dealers in New York and Paris, to keep one step ahead of an expanding American taste and market for modern French art.

Taking the Plunge

Phillips later saw it as a point of pride that he did not need to leave America to see the best of what was in Paris. Although this cumbersome and layered enterprise placed him not one but two dealers away from the artist's studio, there was also something very immediate about its pace. Short cryptic communications between New York and Washington, either typed recapitulations of telephone negotiations or pasted lines of telegraphed messages, give the sense of works collected rapidly for immediate display. In January 1927 Phillips telegraphed Valentine Dudensing:

PLEASE SEND MATISSE AT ONCE AS WE ARE REHANGING NEW EXHIBITION OF IMPORTANT FRENCH AND AMERICAN PAINTING MONDAY.[35]

At the same moment Phillips telegraphed Knoedler & Co.:

I LIKE THE BONNARD VERY MUCH AND WOULD APPRECIATE IT IF YOU COULD LET US KEEP IT ON APPROVAL AND HANG IT AS A LOAN IN AN EXHIBITION OF IMPORTANT FRENCH AND AMERICAN PAINTINGS WHICH IS TO FEATURE

Man Ray,
Georges Braque in His Studio
(ca. 1929) (Courtesy
of Man Ray Trust © 1991
ARS NY/ADAGP)

21

BONNARD WITH A WHOLE WALL OF HIS WORK.[36]

Some works arrived on trial only to be sent back. Two Matisses arrived in the spring of 1927, only to be traded in the fall along with another flurry of purchases, when Phillips saw what dealers brought back from Europe. Reinhardt wrote to Phillips:

Have returned this morning on the Majestic and learned that you have called on me in my absence, also that you are in the market for a Picasso. I have bought marvelous contemporary pictures.[37]

In anticipation of his fall show Phillips told Kraushaar, "We need a Matisse landscape"[38] and reminded Durand-Ruel, "Braque is one of the few Modernists who interests me and I must have a good example of his work."[39] Kraushaar telegraphed the following:

I AM SHIPPING YOU BY TODAY'S EXPRESS ONE BOX CONTAINING PAINTINGS BY SEGONZAC AND DERAIN THAT YOU KINDLY PURCHASED.

This shipment arrived with little time to spare for Phillips's fall show, "Leaders of French Art Today."[40]

A Period of Great Painting

In little over twelve months, Phillips's contemporary French collection had gone from two to fifteen, enough to fill the Little Gallery for an exhibition. To walk into this room, Phillips then surmised, was "to realize that we are privileged to live in a period of great painting."[41] Around the perimeter of the gallery Phillips hung his announced favorite, Bonnard, as well as very particular selections of late arriving French modernists—Matisse, Picasso, Braque and Derain.

In Matisse's *Anemones and Mirror* (1919) Phillips bridged the "short span" leading from Bonnard's evocative sensations to demonstrative color. He must have appreciated that in the hands of a lesser artist the

daring dark oval mirror could have ruptured rather than unified the dabbed clusters of red and blue flowers. And yet, Phillips remained restive in Matisse's "plastic universe," admitting the painting "just misses ecstasy."[42] He would continue to look but would never find a more contemporary resolution for this artist. Perhaps more extreme at this point was Phillips's rejection of the contemporary machinations of Picasso, which he shunned altogether, reaching back instead to the somber, sonorous *The Blue Room* from 1901.

By contrast, Phillips believed the years 1926 and 1927 had captured Braque and Derain at precisely the moment when they had reached the fulfillment of their powers. With *Plums, Pears, Nuts and Knife* (1926) Braque approached the height of his decorative style. This narrow horizontal canvas, shaped very much like the table top which it describes, is at once architectural and pictorial in proportion. It obviates the need for taut cubist geometry. Like the well-measured environs of Braque's newly designed studio on Parc Montsouris, the painting's narrow shelf of space provides a readymade course for the artist's imagination. Loose thick strokes suggest the ebb and flow of the forms of swelling plums and pears and wizened nuts. Their subtle harmonies of brown, green and purple cluster by twos and threes, and float around the complementary plate, glass and knife. A rhythmic cadence more akin to poetry than painting provided Phillips with a pleasing analogy as well as an apt reflection on the refined and solitary Braque in post-war Paris, the artist who made cubism "a thing of exquisite taste."[43]

Though Phillips was hardly one to be playing to the crowd, he seems to have taken up a popular cause with Derain, who was at the time being touted by the press as second only to Picasso or Matisse. *Landscape in Southern France* (1927) opened a window to Derain's clearest vision of

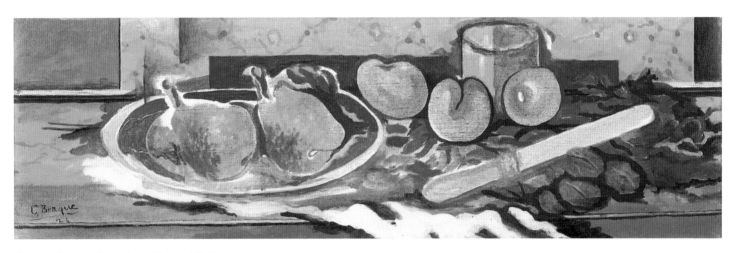

Georges Braque, *Plums, Pears, Nuts and Knife*
1926) oil on canvas, 9 x 28-3/4 in.

the Renaissance. The rectangular panoramic vista, the path winding toward the olive grove, and the distant scheme invoke what Phillips saw as, "the clear Italian landscape," and the birthplace of western painting.[44] Returning to the source was Derain's passion—the great crucible of his art. In this landscape the artist uses bold, even stretches of paint, which open up a great band of sky and establish the solid yellow-brown foundation of earth, where well-placed incisive strokes animate the field and trees as they recess into the distance. Though Derain had made his pilgrimage to Italy in 1921 and traveled often in his Bugatti to the south of France, it is difficult to say exactly where the painter happened upon this scene. Indeed, this restless

modernist required no fixed address for his idealized realm of finely honed classical insights save for the Louvre, where after the war he made a sharp turn, in Phillips's words, toward "the grand manner, the classic order and rhythm of Poussin."[45]

What Happened Is Now Very Clear

With these paintings now in his gallery, the question of continuity became increasingly self-evident. In late 1927, at the end of his feverish twelve-month initial exploration, Phillips wrote:

The continuity of the great tradition in French art is the pride of the best French painters. They seem to realize that a

23

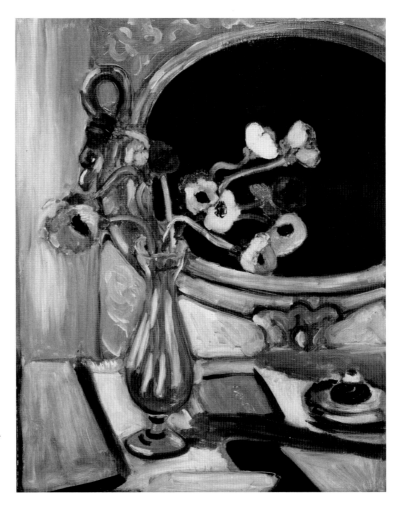

Henri Matisse, *Anemones with a Black Mirror* (1919) oil on canvas, 68 x 52 in.

André Derain, *Southern France* (1927) oil an canvas, 30 x 36-3/4 in.

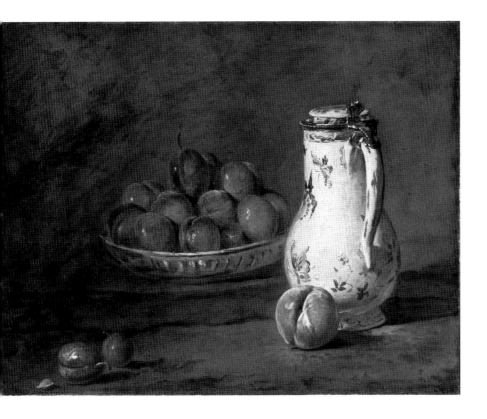

tradition, like an old family, must constantly renew itself with the body and soul of each new age, As we approach the end of a half century of experiment we realize with relief there has been no break with the past. What happened is now very clear.[46]

Phillips saw something substantial emerging from the "revolutions and reactions." Where he once saw anarchy, he now saw a continuum of "great men with great personal conceptions and emotions."[47]

Starting with a 1928 exhibition titled "A Survey of French Painting, Chardin to Derain," Phillips began to demonstrate the "heritage of qualities" in French art, highlighting Chardin's "muffled radiance" and "plastic vision," Derain's "classic order," Braque's "clarity of light," Courbet's "solidity," Cézanne's "architectonic vision," Van Gogh's "emotional color complexes" and Bonnard's "paean on light."[48] Since Phillips collected both nineteenth and twentieth-century works during the late twenties, these correspondences in some cases turned out to be self-fulfilled prophecies. Nowhere is this more evident than in the remarkable comparison between Cézanne's *Mont Sainte Victoire* (1886-87), purchased from Rosenberg in 1926, and Bonnard's grand vista *The Palm* (1926), purchased from Felix Fénéon through de Hauke in 1928. Taking his cue from Cézanne, Bonnard penetrates the hilly vista with a successive array of patterns starting with the leafy foreground frame. Whereas Cézanne let this order stand as a fixed conclusion, Bonnard could not resist the temptation to revel in the white hot Mediterranean light. As if suddenly coming outdoors, our eyes unaccustomed to the glow, we find the shadowy blue Eve beckoning beyond to a world ablaze in dense passages of pink, red-orange and yellow-green.

Paul Cézanne, *Mont Sainte-Victoire* (1886-87)
oil on canvas, 23-1/2 x 28-1/2 in.

Phillips's purchases over the next three years continued to explore a range from the clearly representational aspects of Derain to the more imaginative improvisations of Bonnard and Braque. In each he found some aspect of post-war Paris's new classicism, with its implicit call to order, clarity and balance. Given Apollinaire's 1916 endorsement, Derain's affiliations with this context are perhaps most clear. In addition to

Landscape in Southern France, Phillips quickly purchased *Mano the Dancer* (1928) and *Head of a Woman* (1927). The simplicity and solidity of both portraits finds an immediate complement in Despiau's bust of *Madame Derain* (1922), bought from the sculptor's first American show at Brummer Gallery.

Finding a rivalry not unlike that which existed in Paris in 1830 between Delacroix and Ingres, Phillips de-

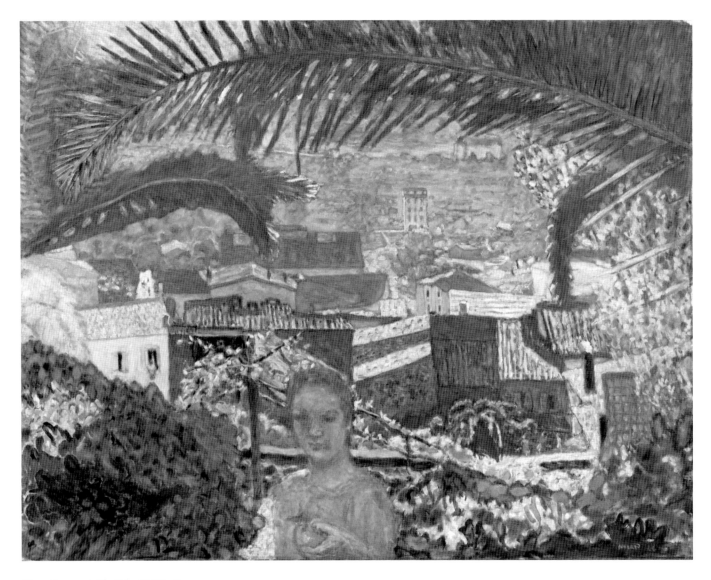

Pierre Bonnard, *The Palm* (1926) oil on
canvas, 45 x 57-7/8 in.

scribed an underlying tension in
contemporary French modernism
between instinctive color and system-
atic design.[49] Phillips found a new
romanticism in Bonnard's slender
vertical slice of yellow-green and
violet landscape titled G*rape Harvest*
(1926). His earliest descriptions of the
painting conjure a vision of arcadia—
a "Keats-like quintessence of 'dance
and Provencal song,'" "washed clean
of preconceptions" in new color.[50]

While he wanted the analytical light
and color of Matisse's paintings from
Nice to serve as a counterpoint to
Bonnard, the right example always
eluded him. In December 1929,
Phillips wrote to Valentine Dudensing
about what he saw but could not
have, about the "Matisse I have
always wanted" "reproduced on page
24 of *Art News*."[51]

Increasingly Phillips turned to
Braque's reasoned, well-measured

27

Pierre Bonnard, *Grape Harvest* (1926) oil on canvas, 25 x 15-3/4 in.

harmonies as the Apollonian counterpart to the emotive and more fluid Dionysian Bonnard. By 1931, with Braque's presence secured in the Collection by the purchase of two major works, *Still life with Grapes and Clarinet* (1927) and *Lemons and Napkin Ring* (1928), Phillips clearly indicated his preference for Braque's orderly tabletop abstractions over Matisse and, for that matter, over the more analytical cubism of Picasso, Marcoussis and Gris, each of whom is represented in the Collection by small post-1914 panels. Of the three, Juan Gris's *Abstraction* (1915), obtained from the poet and critic André Salmon to whom it is affectionately inscribed by the artist, is of exceptional quality. Its immediate, heraldic conjunction of silhouetted goblet, sandy paint, wood graining, lettering and broken color serve as an interesting comparison alongside what Phillips saw as Braque's "timeless" designs. Phillips believed Braque had derived a "classic order" by eliminating analytic cubism's simultaneous "extraneous" messages, and by working within self-imposed ranges of form, texture and color.[52] Phillips later recalled how this became clear to him, how the issue of cubism paled in the light of Braque's new found classicism when standing before *Lemons and Napkin Ring* (1928) one afternoon in the winter of 1930:

Last winter I was in my study one day absorbed in a book on archaic sculpture and primitive ornament. Friends arrived and asked to see the Braque which was then the over-mantel in the dining room. While they spoke of its curious novelty I wondered at its stately antique grandeur, wondered why it seemed so much like the constructions of antiquity that I felt no break, no interruption in passing mentally from ancient civilizations to the adventuring modern mind.[53]

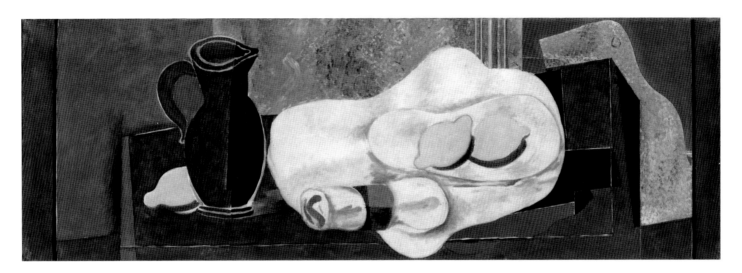

Georges Braque, *Lemons and Napkin Ring*
(1928) oil on canvas, 16 x 47-1/2 in.

Modern Art 1930

On the occasion of the newly founded
Museum of Modern Art's third
exhibition, "Painting in Paris,"
Phillips paused from his own mu-
seum duties to write an editorial
commentary titled "Modern Art
1930."[54] He did not use this as an
occasion to comment on the specific
contents of the show, though he was
quite familiar with them. He had
been a major lender, contributing
works by Bonnard, Braque, Derain
and Picasso. The curator/director
Alfred E. Barr, Jr. was someone
Phillips had known since 1927.
Phillips was made an honorary

trustee of MOMA when Barr became
director in 1929. Barr, also a student
of the Renaissance, voiced his agree-
ment with Phillips's approach.
Remarking upon their shared interest
in modern painting and art of the
past, Barr wrote Phillips, "Are we not
both experimenting in the same
problem, though you are far ad-
vanced?"[55] There was every reason to
see this occasion as an affirmation.
Yet something about this exhibition,
this particular celebration of the
School of Paris, would make Phillips
feel an outsider, causing him to step
back and assess the situation quite
differently.

Phillips's editorial first commented

29

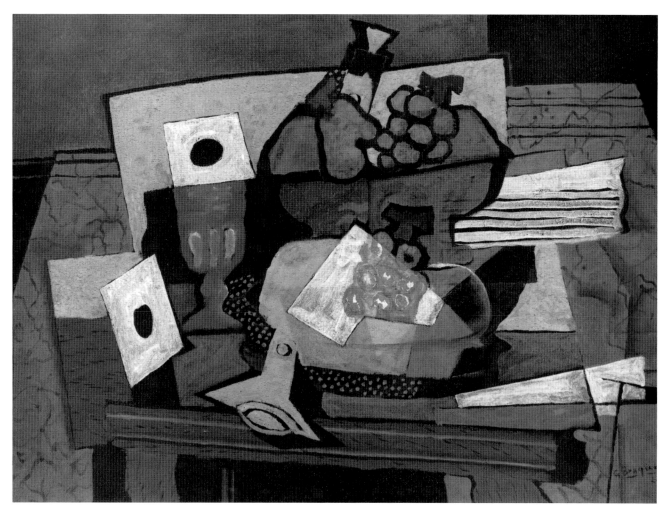

Georges Braque, *Still Life with Grapes and Clarinet* (1927) oil on canvas, 21-1/4 x 28-3/4 in.

on the number of people coming to the exhibition, an average of over 3,000 on Saturdays, 35,000 in three weeks.[56] This took him back to another occasion nearly seventeen years earlier when crowds flocked to see new art from Paris. He "doesn't see the curiosity mob which packed the celebrated Armory Show of 1913." Here was "an entirely different manifestation."[57] He interpreted the changed tone of the audience as a sign of acceptance and understanding. He surmised, "Modernism has become a fait accompli,"[58] and American audiences are thoroughly "habituated to a new language of design."[59] In many ways Duncan Phillips was commenting on his own journey of acceptance.

More than four years after beginning his exploration of Parisian moderns Phillips now understood many dialects, from machine age syncopations to the realm of subconscious or "hidden states of mind."[60] These were, in his words, "logical equivalents in art for the age which has produced Freud and Einstein."[61] He saw the instantly recognizable but ever changing public profiles of Picasso and Matisse leading the way, not so much ahead of their time but in step with it. Phillips was also well

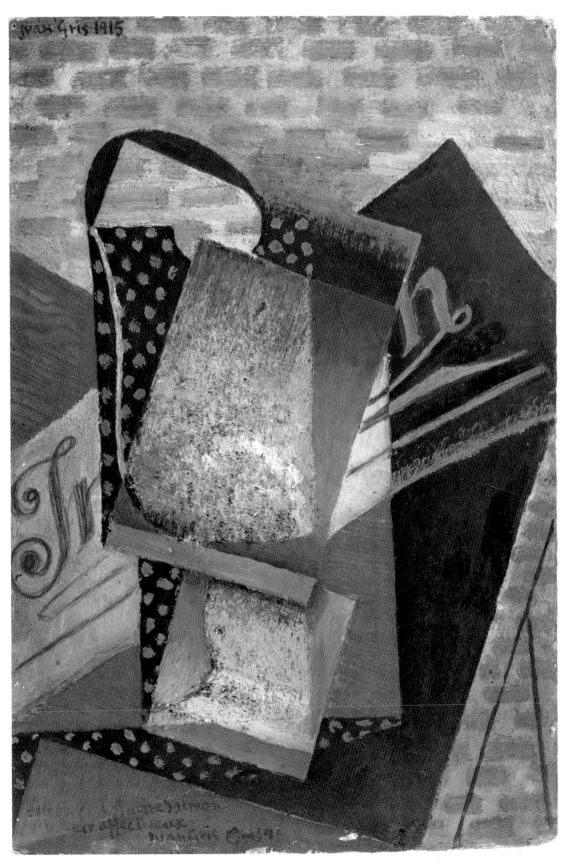

Juan Gris, *Abstraction* (1915) oil and oil with sand on cardboard, 11-3/8 x 7-3/4 in.

enough positioned to see how this exhibition reflected Barr's desire to keep apace with the public's appetite for new painting. Interestingly, at the moment when he saw Barr heading where "the current of progress flows swiftest,"[62] Phillips stood against it and announced a less popular alternative, away from topical artists whom he saw "breathlessly followed and acclaimed."[63]

At the heart of it was Phillips's disappointment over the lack of recognition for Bonnard, then being denounced as "a false prophet of escape from the hard facts of modern life."[64] In the face of this criticism, Phillips maintained that Bonnard used the means of the bygone era of impressionism but achieved a completely forward-looking expression. In this respect Bonnard's vision, like that of El Greco, Rembrandt, Cézanne, or Van Gogh before him, was misunderstood by his times. Phillips wrote:

What matters it if Bonnard, like Cézanne, belongs to the ages? The New York dealers and collectors repeating propaganda from Parisians who are speculating on other painters easier to collect, pronounce that he is not of the hour.[65]

Beyond this prejudice, Phillips seized onto the overriding issue of color—or rather the American public's inability to appreciate it and his overwhelming allegiance to it. His closing remarks sketch a profile which in many ways drove his decisions in the decade to come, when expressive color would predominate his contemporary French collection:

They [colorists like Bonnard] are more difficult for the American connoisseur than the most cerebral Picasso or Leger. Why? Because they require sensibility for color, which is as yet, undeveloped in this country They are the genuine modernists who dare to be different from the mode of the moment, men who are altogether inimitable, and who, for that reason, will found no Schools and create no collective art. The future, however, may belong to them. The time element

will surely come into painting and with it a renewed reverence for those painters who can move men to ecstasy and vision through their divine control of the emotional potentialities of light and color.[66]

Expressive Color

By the thirties Phillips was confident that color was the unifying theme of his taste and direction. His writings at this time refer to "color not applied to, but identical with form,"[67] not "limited and local," but color as "the direct instrument of painting."[68] By 1941, with his exhibition titled "The Functions of Color in Painting," Phillips's considerations became more systematic, positing a range from prismatic to dynamic or emotive color. In so doing there would be omissions. Neoplasticism and surrealism—the extremes of formalism and expressionism—were left out altogether during this period. Over the next ten years his contemporary French purchases focused upon three major colorists—Georges Rouault, Raoul Dufy and Chaim Soutine. Though he found key examples of Rouault and Dufy early in the decade, the major portion of works by all three artists came into the Collection between 1937 and 1943. In their work he found a range from lyrical escape to tragic recognition that spoke to the growing discomfort of a generation facing the shadows of yet another war in Europe.

In 1931 Phillips was seized by the brooding "dark lyricist,"[69] Georges Rouault. True to Phillips's 1930 profile of his ideal colorist, this artist was a self-proclaimed loner. A man of deep faith, his subjects—circus performers, prostitutes, dancers, judges or priests—were not merely topical but religious. His deep colors and dark contours invoke stained glass windows—mystical themes showing light overcoming darkness,

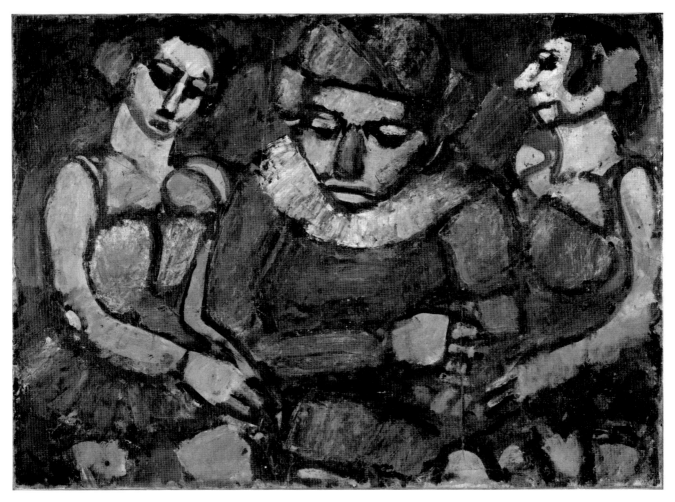

Georges Rouault, *Circus Trio* (1924) oil on
paper, 29-1/2 x 41-1/2 in.

suffering and transcendence. As
Rouault explained:
*I do not feel as if I belong to modern life
on the streets where we are walking at this
moment. My real life is back in the age of
the cathedrals.*[70]

Save for exhibiting with the fauves
at the Salon d'Automne of 1905,
Rouault was often out of step with
modern movements. Like Daumier
before him, he was both a printmaker
and a painter. His response to World
War I was to undertake a print series
titled *Miserere et Guerre*, which
occupied him for most of the twenties.
In the thirties Rouault enjoyed a
second career as a modern painter
and once again color was his instru-
ment. In his homage to Renoir,
Rouault declared a fate not unlike his
own, "Glory to you for often having
been drunk with color when so many
others sought only a mediocre success
and withered away."[71] Long after
Picasso had abandoned the blue
harmonies and outcast subjects of his
bohemian youth, Rouault kept his
focus and renewed his palette.

Among Phillips's earliest pur-
chases was an imaginary portrait
titled *Circus Trio* (1924), in fact the
earliest work by Rouault to enter the
Collection. Rouault often went to the
Cirque Fernando, Nouveau Cirque,
Cirque d'Hiver, and Cirque de Paris,[72]
documenting in his sad commentary

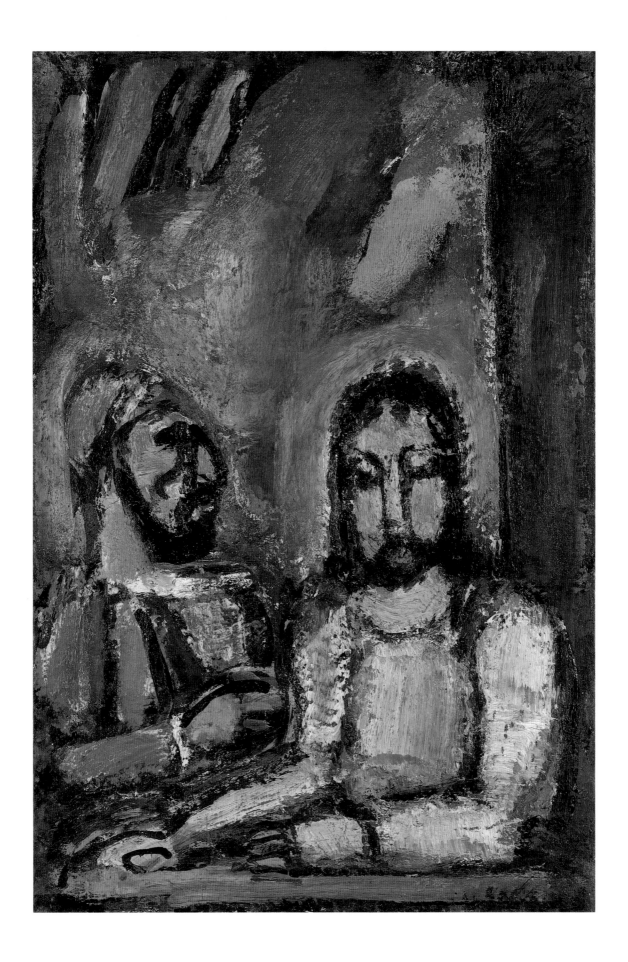

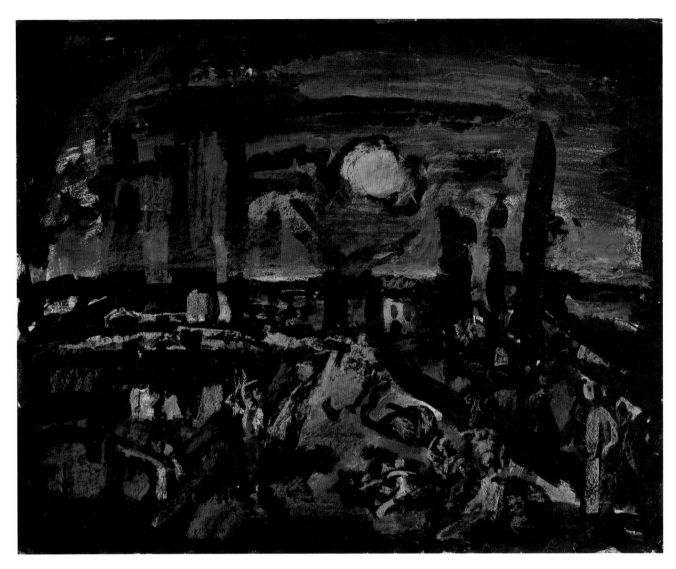

Georges Rouault, *Tragic Landscape* (1930) oil
on canvas, 18-3/4 x 23-1/2 in.

Georges Rouault, *Christ and the High Priest*
(ca. 1937) oil on canvas, 18-7/8 x 12-7/8 in.

what few circus spectators expect to find. Two *écuyères* (circus girls) hold the arms of a hunched old clown. His downcast eyes, ringed by dark, cavernous sockets, cast a pallor of death which his fringed collar and floppy hat cannot chase away. Yet, as this hulking, somber green form emerges from the dark ground and advances, the viewer gets a glimpse of the hope and the struggle for yet another performance. This image brings to mind the stalwart spirit of the bent and twisted Renoir who asked for the brush to be tied to his hand so that he could continue to paint. Rouault certainly saw himself and perhaps his own creative struggle in the clown. As he commented, "I saw quite clearly that the clown was me, was us, nearly all of us."[73] Rouault later turned his attention towards overt biblical references such as *Christ and the High Priest* (ca. 1937), where one views the confrontation between the Man of Sorrows and his

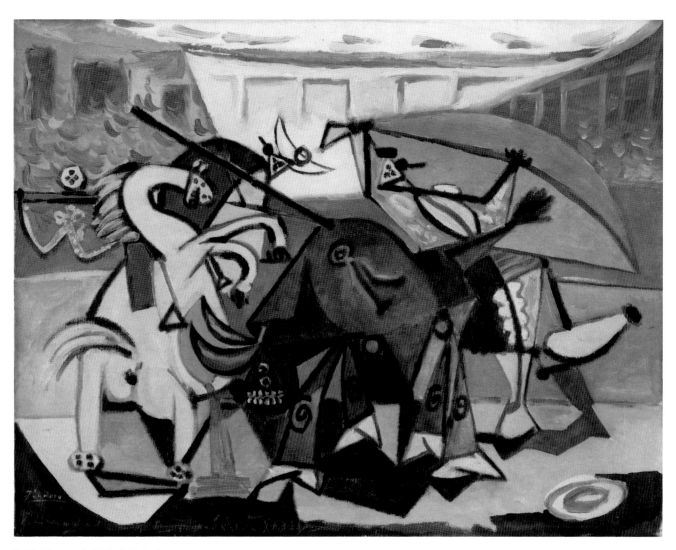

Pablo Picasso, *Bullfight* (1934) oil on canvas,
19-5/8 x 25-3/4 in.

Accuser through jewel-like illumina-
tions of green and orange bound by
dark borders.

Phillips's initial preference had
been for Rouault's landscapes, which
were closer to the realities of nature.
Rouault called them his "stepping-
stones."[74] Gazing out at the horizon,
he aimed for nothing less than
Rembrandt's visionary vistas. In a
gouache titled L*andscape* (1930), which
Phillips acquired in 1931, dark blue
diagonals engulf the conflict of the
protagonists and rising streaks
threaten to snuff out the yellow-
orange sun. Moved by this arrange-
ment of color, Phillips renamed the
painting *Tragic Landscape*. Soon after,
he declared Rouault profoundly
conscious of "man's tragic fate in a
world volcanic with its eruptions of
evil forces."[75] No doubt he found
similar intensity—which he referred
to in Rouault as "a personal, untamed,
almost pathological emotion of
mingled ardor and anger"[76]—in the

maelstrom of dark line and color of Picasso's *Bullfight* (1934), which he acquired in 1937. However, Rouault's *Afterglow, Galilee* (before 1930), purchased in 1939, would offer him a more resonant vision and subtle sense of pathos. Weighty stretches of saturated pigment create a sunset glowing yellow-red-orange against the dark horizon. The dying light casts a lugubrious blue-green upon the water and from it rises a yellow-orange mist which intensifies as it meets the sky. In the distance a fishing boat with its thin mast etched against the heavens suggests the vigil of those who once waited in the wake of Calvary.

Phillips found a stunning contrast to Rouault's somber meditative landscape in Raoul Dufy's *Seaside Motifs* (1927), purchased just the following year in 1940. Bright, clear tones convey untrammeled vistas of boats, bathers, beaches and the sea. There are no bounds to the exuberant expanse of ocean. Its blue pushes against the land and fills the sky. Waves and clouds register alternately white and blue against it. Scribbled notations take on the character of plants or steamers or swimmers, often leaving in their wake a curious realm where a giant butterfly might hover above a small skiff. Presiding in the foreground the goddess Ceres, surrounded by her harvest of plenty, suggests an age of innocence before the fall.

When Phillips turned to Dufy, he found equal need for and validity in an art that made "no claims to profundity" and offered "no solemn sarcastic meanings."[77] He respected Dufy "for remaining young despite worldly wisdom."[78] While on the one hand Phillips celebrated Dufy's spontaneity and exuberance, he also saw technical virtuosity underlying the artist's seemingly simple renderings. (In praising Dufy for surmounting difficulty with effortless grace, Phillips issued the compliment most treasured by Renaissance artists.)

Phillips wisely distinguished Dufy's bright prismatic color from impressionism, a favorite analogy of critics at the time. Citing the counterpoint of calligraphic line and ambient tone, he looked instead to the precedent of the Japanese printmaker Hokusai. As he wrote:

But now Dufy, unlike Monet and more like Hokusai, emphasizes the individual artist's joy in a handwriting of synthetic design instead of his analysis of color as light.[79]

Nevertheless, for Phillips, Dufy remained the supreme uncomplicated extrovert—the boulevardier out and about. His collection came to include by the end of the decade a full range of Dufy's observations, from the Paris Opera to Versailles, from the regatta at Joinville to the race courses at Epsom. Though the 1942 Rouault retrospective was more prominent in his mind "against the fiery background of the Second World War,"[80] Phillips brought out and exhibited Dufy in 1944, like some stored and treasured wine, to celebrate "liberated" France.[81]

By 1940, with the reality of war closing Europe off from America, Phillips increasingly associated French painting with a more vulnerable expressive vision. In *The Dream* (1939), purchased in 1942, Marc Chagall's "innocent eye" seemed to possess past happiness through a poetic reversal of interior and exterior views. Immediately before us is an embracing couple in the privacy of their bed, visited by an angel. Behind them rises the blue floating world of their village. While Phillips admired this powerful visionary sequence, he relied more heavily on Soutine's anxious impressions from the French countryside.

Phillips's first purchase, titled *Return from School After the Storm* (1939), was among the last of Soutine's works to make it out of Europe. The painting, immediately hailed as a "premonition of our

Georges Rouault, *Afterglow, Galilee* (before
1930) oil on paper mounted on canvas,
19-3/4 x 25-5/8 in.

world's agony of total war,"[82] was
renamed *Children Before the Storm*
when it was brought to the museum
in 1940. In the summer of 1939
Soutine painted scenes around the
village of Civry-sur-Serein. Firsthand
accounts of this period portray
Soutine roaming throughout the
countryside, frenetically scanning the
landscape of poplars much as he
scanned the newspaper reports of
German rearmament and Hitler's
demand for the return of Poland.[83]
That summer Soutine's lush pigments

and spiralling brush described the
journey of two small, shrouded
children bracing against the wind as
they rush out of a towering grey-
green forest, down the road to L'Isle-
sur-Serein, a route that would offer
little hope of escape for Soutine when
Hitler's military turned westward.
(Unlike his compatriot Chagall, who
was sponsored by Washington
collector John U. Nef through the
efforts of the American Emergency
Rescue Committee, Soutine refused
the opportunity to leave Europe.)

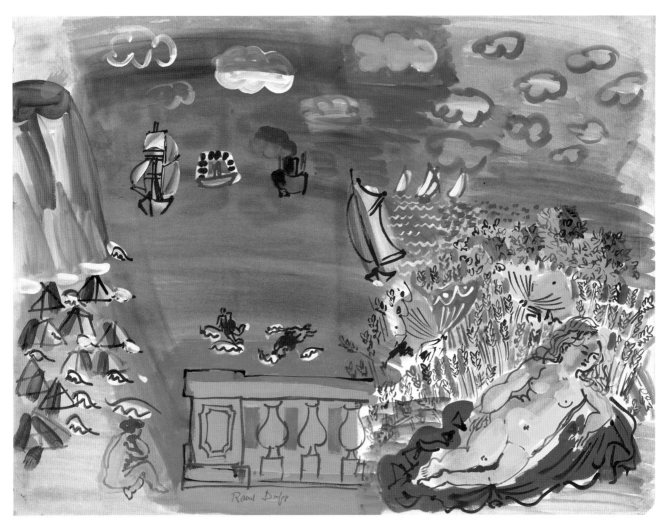

Raoul Dufy, *Seaside Motifs* (1928) watercolor
and gouache on paper, 19-3/4 x 25-3/4 in.

In 1943, the year of the artist's death, Phillips mounted a show of Soutine's work. Out of the exhibition of borrowed works, Phillips purchased a 1937 portrait from the Carroll Carstairs Gallery. The subject is tentatively identified as Madame Tennent, wife of a Viennese refugee doctor who briefly treated Soutine for his life-threatening ulcer condition. According to this source, this rendering was painted in an afternoon.[84] The highly simplified black figure with dripping green and red accents

would seem to confirm this. It seems doubtful that the sitter kept the portrait, as it passed from Madame Castaing, Soutine's friend and dealer, to the Carstairs Gallery in a matter of two years. In this seated figure Soutine did not find the soulful accepting gaze that fellow bohemian Amedeo Modigliani found in his supporter and friend Elena Povolozky. With arms crossed, Madame Tennent's tightly wound body twists in the chair and her head turns away, averting the gaze of the

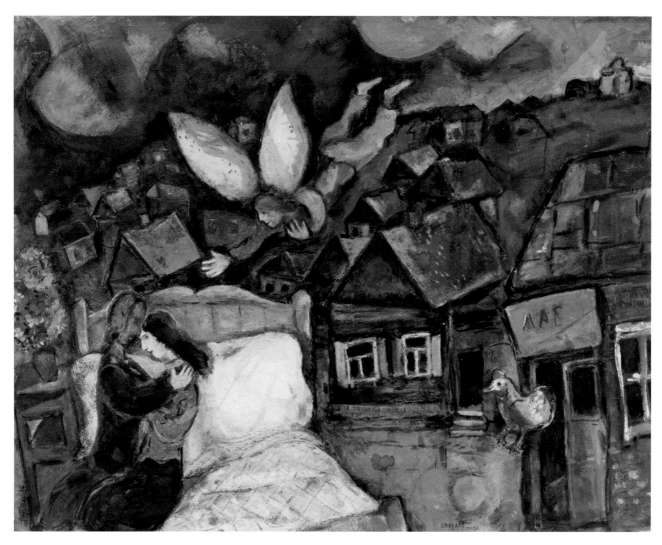

Marc Chagall, *The Dream* (1939) gouache on
paper, 20-1/2 x 26-7/8 in.

artist whose aerial perspective seems
to be bearing down upon her. Given
Soutine's notorious lack of personal
hygiene, this could hardly have been a
pleasant experience for a stranger.

Phillips's passionate interest and
concern for Soutine at this moment
must also be seen as an unlikely
combination of refinement and
squalor. Phillips continued to draw
closer to the more vividly grotesque
aspects of Soutine's vision. His last
purchase, *The Pheasant* (1926), is in fact
the earliest Soutine in the Collection.

The bird's withered form, blue-black
in the neck with rivulets of red, recalls
the times when Soutine walked
Parisian markets in search of the
perfect ripe and rotting fowl for his
dead bird series. Here indeed are the
pure applications of fauve color which
Phillips, the young poet, found
distasteful and crude at the time of the
1913 Armory Show and Phillips, the
young director, did not look for in
Paul Guillaume's gallery along the
rue de la Boëtie in the summer of
1923. A generation later, Phillips

found something masterful in this painting of an attenuated carcass writhing with strokes of color. It is, after all, a vision attained through the qualities Phillips most admired, namely "original inspiration and personal expression."[85] In *The Pheasant* Phillips saw Soutine living up to his gifts, ambitions, and discoveries. Ultimately, such self-prescribed artistic standards were paramount in this collector's mature judgment.

Conclusion: Late Trades and Modern Masterworks

It is not I that change my mind about the painting but the paintings disappear into the wall.[86] (Gertrude Stein)

The issue of standards in modern art was perhaps at the crux of Phillips's desire to collect and to form his "American Prado." It was the lack of standards, or his confusion over them, that drove him away from the Parisian avant-garde at the Armory Show. And it was only after certain assurances of continuity in artistic values that he returned to the avant-garde in the twenties. Both sides seemed to have found common ground in the ideals of the past. Though some would mark him tardy, Phillips believed that he had arrived just in time, referring to this moment as "a period of great painting."[87] The experiments for which the avant-garde had banded together in the past seemed only a preparation for future personal expressions and eventually, grand summations. Starting with Bonnard, Phillips found a range and depth of color that would become the signature of his collection. In contrast with his first survey of 1927, this was not accomplished in haste, but through years of deliberate culling which often involved painful trades and, at times, fierce competition, in order to seize the opportunity to acquire key paintings with the scope and scale of masterworks.

In the fall of 1930, Phillips, through Paris agent C. M. de Hauke, now of Jacques Seligmann & Co., began negotiations with a private collector for the purchase of Bonnard's *Open Window* (1921). In October, de Hauke wrote Phillips, "I have just this minute received by cable good news from Paris."[88] Phillips told de Hauke that if he was unable to pay the prescribed amount in the proposed time frame, he would offer paintings for consignment in the following order: Monet's *Basket of Fruit*, Bonnard's *Woods in Summer*, and Derain's *Still Life*.[89] With Bonnard still not a popular choice in America, Phillips again found it necessary to deal directly with Paris in the purchase of *The Terrace* (1918) in 1935.

Forays to Paris to find the quintessential Picasso and Braque seemed unnecessary with the December 1933 arrival in New York of Paul Rosenberg, a self-described dealer of masterworks, and not "modern art,"[90] who had first pick from Picasso and Braque's studios during the crucial years of the twenties. In March 1934 Durand-Ruel's New York galleries exhibited Rosenberg's private store of paintings by Matisse, Picasso and Braque.[91] In this exhibition, Phillips found Braque's *Gueridon (The Round Table)* (1929), Matisse's *Torse* (1919) and Picasso's *The Three Musicians* (1921) most desirable. While the Matisse was secured the following month by trading Monet's *Melon & Fruit* and Fantin Latour's *Portrait of Sonia*, the other two paintings from Rosenberg's collection became matters of greater contention. Ultimately, Phillips set his sights upon Braque's *The Round Table,* while Alfred Barr focused on a painting of equal scale, Picasso's *The Three Musicians*. Phillips secured the Braque by paying for it outright in June. By October, it was installed in an exhibition of French paintings in the Main Gallery just in time for the arrival of Gertrude Stein. Barr, meanwhile, was obliged to content himself with a loan from

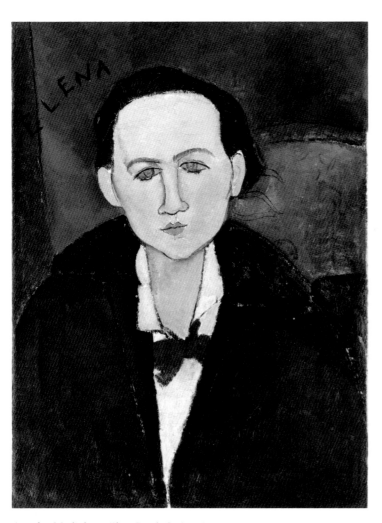

Amedeo Modigliani, *Elena Povolozky* (1917)
oil on canvas, 25-1/2 x 19-1/4 in.

Chaim Soutine, *Woman in Profile* (1937) oil on
canvas, 18-1/2 x 11 in.

Chaim Soutine, *The Pheasant* (1926) oil on
canvas, 12-1/4 x 29-3/4 in.

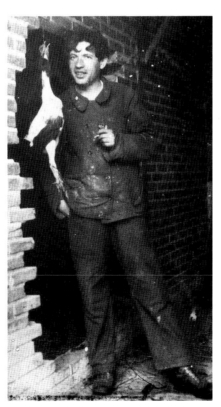

Chaim Soutine with a Dead Fowl (Courtesy of
the Collection of Billy Klüver and Julie
Martin)

Rosenberg of *The Three Musicians* for
his exhibition at the Museum of
Modern Art the following year, and
for his 1939 Picasso retrospective as
well. In 1941 Phillips tried out *The
Three Musicians* in his Main Gallery,
through a loan from Rosenberg, with
no more conclusive results. In the
meantime, Albert Gallatin, through a
great coup, secured from a London
gallery a second, practically identical
version of *The Three Musicians* which
had passed from Picasso to Rosenberg
in 1925.[92] Barr's "congratulatory"
note to Gallatin conveyed the sense of
competition which must have existed
between all three directors at the time.
Barr wrote:

*I won't conceal a slight tinge of bitterness
in my congratulations. As you will
remember, it must be at least three or four
years since we had luncheon together and
I told you of my great desire to purchase
this picture for the Museum. After a year
campaign I was unable to do so. The
Museum's failure—or my own, I am not
quite sure which it is—is the worst*

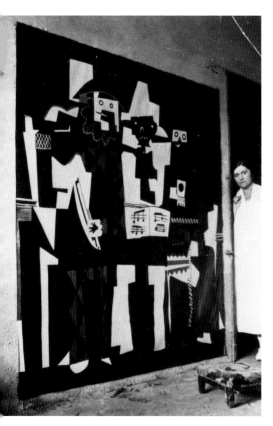

Olga and The Three Musicians, Fountainebleau
(1921) (Courtesy of the Archives Picasso)

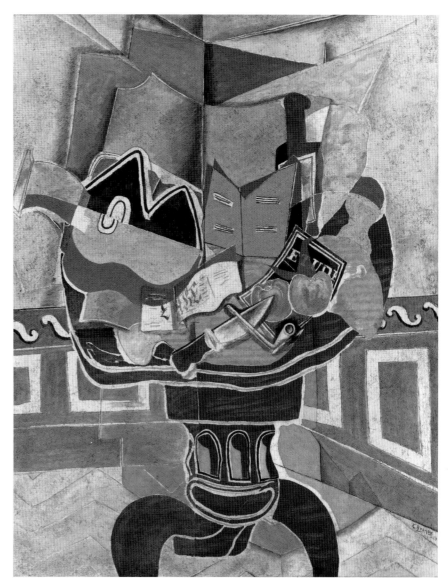

Georges Braque, *The Round Table* (1929) oil on
canvas, 57-1/4 x 44-3/4 in.

Raoul Dufy, *The Artist's Studio* (1935) oil on canvas, 46-7/8 x 58-1/4 in.

Georges Rouault, *Verlaine* (ca. 1939) oil on canvas, 39-3/4 x 29-1/8 in.

disappointment I have had in my seven years as director.[93]

In 1940, Phillips accepted an offer from Pierre Matisse to purchase *Studio, Quai St Michel*, his father's grand studio painting from 1916, which Barr had exhibited in MOMA's 1931 Matisse retrospective. This painting, now popularly acclaimed as a "landmark of Modern Art," supplanted Matisse's paintings from Nice in Phillips's imagination. Although it was not necessary to make such a sacrifice to acquire *The Artist's Studio* (1935) by Dufy in the spring of 1944, in 1947 Phillips parted with Matisse's *Anemones and Mirror* and *Danseuse*, as well as Chagall's *La Ville* in order to secure Rouault's *Verlaine* (ca. 1939). Confident of his decision, Phillips wrote to Rouault's biographer Lionello Venturi proclaiming the work a "supreme masterpiece."[94]

Together, these grand summations by Bonnard, Matisse, Braque, Dufy and Rouault say something about Phillips's final understanding of the Parisian moderns and their great moment between the world wars. Each work possesses an autobiographical thread that speaks to the self-consciousness of the age, a time when the act of painting was played out in the rarified realm of the studio. These architectural arrangements do not reintroduce Albertian perspective, but allude to the rationalized pictorial space of Renaissance art. The omnipresent open window provides the metaphor for interior and exterior vistas of the modern artist. Phillips saw this most clearly when he wrote that Bonnard "with his brush opens a window" upon "a new world of soaring wings in space and of subconscious life explored."[95]

In Braque's studio depiction, *The*

45

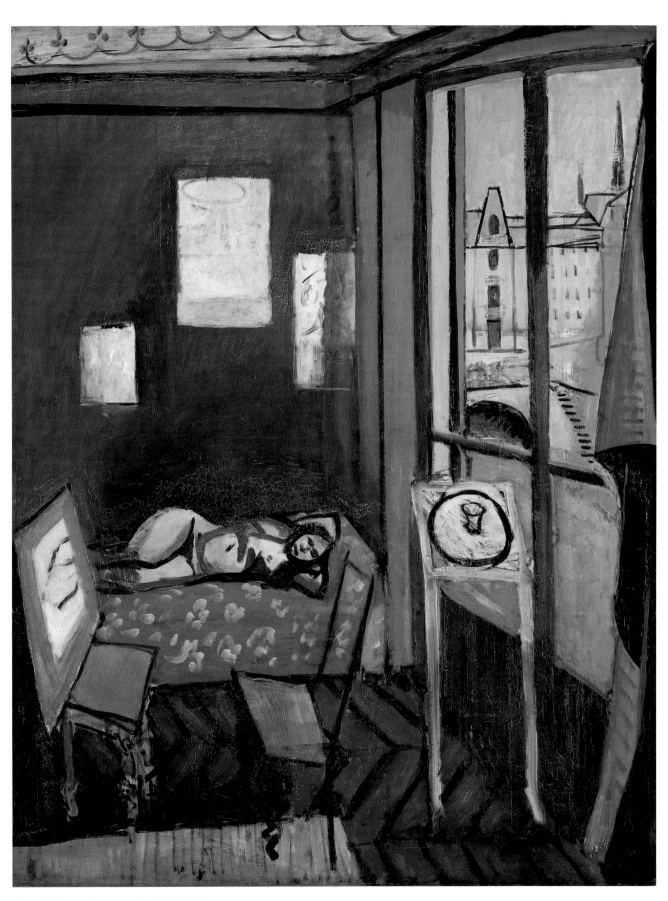

Henri Matisse, *Studio, Quai St. Michel* (1916)
oil on canvas, 58-1/4 x 46 in.

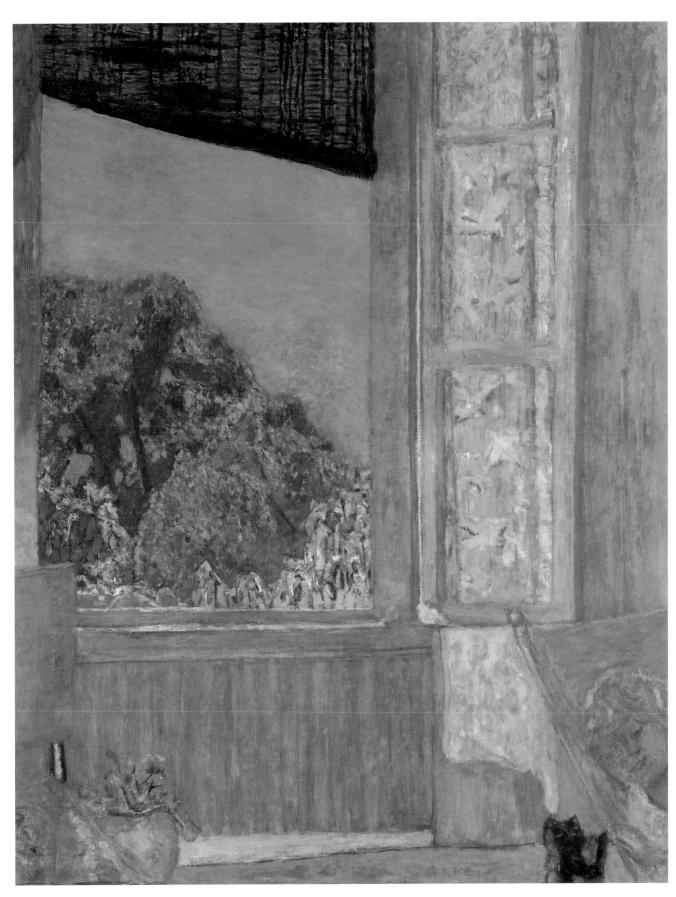

Pierre Bonnard, *The Open Window* (1921) oil
on canvas, 46-1/2 x 37-3/4 in.

Round Table, Phillips found and proclaimed a watershed—

the best style in Europe during that interval between the wars when epicureanism flourished for a little while and when Cubism finally justified itself.[96]

Playing the perfect recital without missing a note or a beat, Braque indeed tilted the great round tabletop and unfurled all the elements of cubism in just the right proportion. Braque inscribed and textured his surfaces so that the guitar, the pipe, the knife, the fruit, the open book and the overlaid sheaves of orange, yellow and green would perfectly suit their allotment of pictorial space. As Phillips initially surmised, Braque's retrospective view would naturally find a companion in Picasso's cubist summation, *The Three Musicians*. While Braque's composition would supply the refined abstract notations, Picasso's configuration of the rhythmic cubist checkerboard with its jots and dashes would supply the merriment of the players—Pierrot on the pipe, Harlequin with the bow, and the Monk with one hand on the keyboard and the other raising his glass for one last toast.

After many trades, Matisse came to rest in the Collection, not in a retrospective moment of exuberant color but in a revealing moment of reckoning, when the artist was reordering his pictorial priorities. In *Studio, Quai St. Michel* the austere black lines which Matisse once used to describe free flowing arabesques now are used to mark out the floor, wall and windows in a narrow, slightly vertical pocket of studio space where the artist's model, empty canvas, and chair await him. The tonality of all his color is so evenly matched that the red of the couch and the blue of the water and sky do not compete with the yellow-brown-gray of the interior. The critic John Russell once ascribed something penitential to Matisse's studio perspective overlooking the Palace of Justice.[97] Certainly, at this

moment, Matisse recanted whatever distractions of color may have previously kept his attention from concerns of pictorial light and space. Perhaps Phillips found something in Matisse's somber composition which invoked Rouault's dark, window-like vision of *Verlaine* (ca. 1939), gazing upon the Virgin Mary and yearning for regeneration. Indeed, he could not have found a greater switch from Matisse's introspection than in Dufy's bright blue studio whose tall windows were open for all of Paris to applaud his artistic accomplishments.

As Phillips always suspected, Matisse found his best companion in Bonnard, from whom he rediscovered the beauty of light. This became eminently clear in Bonnard's *Open Window*, a composition whose space is apportioned similarly to the Matisse's *Studio, Quai St. Michel* installed nearby. Bonnard, the former intimist, melded the warm and cool tones of daylight and closeted shadow, creating a daydream-like atmosphere. The sleeper reclines in a hot steamy room of yellow, orange and violet. The blue cat leaps, catching the tone of the shade which stands askew before the brilliant lavender sky and vaporous green-yellow leafy canopy. Referring to Bonnard at The Phillips Collection, Matisse once told Phillips, "He is the best of us all."[98] Clearly, Matisse and Phillips shared a common hero. It was Phillips's great insight to insist on the modernity in Bonnard's mature style while others in America were dismissing him as anachronistic. Indeed, the legacy of Phillips's collection is a shared legacy with Bonnard, whose color still has the power to inspire future challenges and, yes, "enchant." As Bonnard promised in his journal in 1946:

I should like to present myself to the young painters of the year 2000 with the wings of a butterfly.[99]

Notes

[1] Duncan Phillips, *A Collection in the Making,* (New York: E. Weyhe, 1926), 6.

[2] Phillips discusses his early aesthetic interests in "The Impressionistic Point of View," *Art and Progress* 3 (March 1912), 505-11.

[3] "Revolutions and Reactions in Painting," *The International Studio* 51 (December 1913), cxxix.

[4] *The Enchantment of Art as Part of the Enchantment of Experience: Fifteen Years Later.* 2d ed., rev. (Washington: Phillips Publications, 1927), 46. I would like to thank Leslie Furth for bringing this quote to my attention.

[5] *A Collection in the Making,* 4.

[6] I would like to thank Joseph Holbach for this insight.

[7] *A Collection in the Making,* 6.

[8] See Elizabeth Hutton Turner, *Men of the Rebellion: The Eight and Their Associates at The Phillips Collection* (Washington, D.C.: The Phillips Collection, 1990), 6-25.

[9] *A Collection in the Making,* 3.

[10] DP to Guy Pène du Bois, 20 December 1923 (The Phillips Collection Papers, Archives of American Art).

[11] *A Collection in the Making,* 8.

[12] T. S. Eliot to Robert McAlmon, 2 May 1921, quoted in Robert McAlmon and Kay Boyle, *Being Geniuses Together, 1920-1930* (San Francisco: North Point Press, 1984), 7.

[13] Marjorie Phillips, *Duncan Phillips and His Collection,* rev. ed. (New York: W.W. Norton & Co., 1982), 66.

[14] For a discussion of these Parisian dealers see Malcolm Gee, *Dealers, Critics, and Collectors of Modern Painting: Aspects of the Parisian Art Market Between 1910 and 1930* (New York: Garland Publishing Inc., 1981), 37-87.

[15] Marjorie Phillips, 63-66.

[16] DP to Dwight Clark, 10 July 1923 (TPC Papers, Archives of American Art).

[17] *A Collection in the Making,* 34.

[18] *The Autobiography of Alice B. Toklas* (New York: Vintage Books, 1933), 193-194.

[19] Matisse to Charles Camoin, 19 July 1916, quoted in John Elderfield, *Matisse in the Collection of the Museum of Modern Art* (New York: The Museum of Modern Art, 1978), 112.

[20] I am indebted to Kenneth E. Silver's insights into the avant-garde in wartime Paris, especially his observations about cubism in the service of nationalism. See *Esprit de Corps: The Art of the Parisian Avant-Garde and the First World War, 1914-1925* (Princeton, N.J.: Princeton University Press, 1989), 314.

[21] Guillaume Apollinaire, "André Derain," in *Apollinaire on Art: Essays and Reviews, 1902-1918,* ed. Leroy C. Breunig, (New York: Da Capo Press, 1972), 444-446.

[22] "Pensées et reflexions sur la peinture," *Nord-Sud* 2 (December 1917), 3-5, quoted Silver, 424.

[23] Gris to Kahnweiler, 25 August 1919, quoted in Silver, 314.

[24] I am indebted to Christopher Green for his insights on the post-war legitimization of revolt and the retreat of the artist into his own separate realm. See *Cubism and Its Enemies: Modern Movements and Reaction in French Art, 1916-28* (New Haven and London: Yale University Press, 1987).

[25] Gris to Kahnweiler, 27 November 1921, quoted in Silver, 251.

[26] "Intimate Impressionists," exhibition pamphlet (Washington, D.C.: Phillips Memorial Gallery, 1926), n.p.

[27] "Latest Paintings by Matisse," *Art News* (November 15, 1924,), 3.

[28] "Picasso is Painting in a Classic Style" *Art News* (November 24, 1923), 1.

[29] DP to Edward Duff Balken, 29 October 1925 (TPC Papers, Archives of American Art).

[30] "Intimate Impressionists."

[31] Marjorie Phillips, 75.

[32] "Leaders of French Art Today," exhibition pamphlet (Washington, D.C.: Phillips Memorial Gallery, 1927), n.p.

[33] DP to ELC, 30 December 1926 (TPC Papers, Archives of American Art).

[34] Ibid.

[35] DP to VD, 21 January 1927 (TPC Papers, Archives of American Art).

[36] DP to Thomas Gerrity, 21 January 1927 (TPC Papers, Archives of American Art).

[37] Paul Reinhardt to DP, 11 October 1927 (TPC Papers, Archives of American Art).

[38] DP to John F. Kraushaar, 16 November 1927 (TPC Papers, Archives of American Art).

[39] DP to Joseph Durand-Ruel, 11 April 1927 (TPC Papers, Archives of American Art).

[40] JFK to DP, 28 October 1927 (TPC Papers, Archives of American Art).

[41] "Leaders of French Art Today."

[42] Ibid.

[43] Ibid.

[44] "Derain and the New Dignity in Painting," *Art and Understanding* 1 (November 1929), 81.

[45] "A Survey of French Painting, Chardin to Derain," in *A Bulletin of the Phillips Collection Containing Catalogue and Notes of Interpretation Relating to a Tri-Unit Exhibition of Paintings*

and Sculpture (Washington, D.C.: Phillips Memorial Gallery, 1928), 11.

[46] "Leaders of French Art Today."

[47] "The Many Mindedness of Modern Painting," *Art and Understanding* 1 (November 1929), 58.

[48] For Phillips's discussions of these qualities see "Leaders of French Art Today," "French Painting, Chardin to Derain," and his article on Bonnard which appeared in the 1927 *Bulletin of the Phillips Collection.*

[49] See "French Painting, Chardin to Derain."

[50] Ibid., 21.

[51] DP to VD, 16 December 1929 (TPC Papers, Archives of American Art).

[52] "The Modern Argument in Art and Its Answer," in *A Bulletin of the Phillips Memorial Gallery containing Notes of Interpretation Relating to the Various Exhibition Units,* (October 1931-January 1932), 47.

[53] Ibid., 45.

[54] "Modern Art 1930" in *Art and Understanding* 1 (March 1930), 131-144.

[55] AB to DP, 10 January 1927 (TPC Papers, Archives of American Art)

[56] "Modern Art, 1930," 131.

[57] Ibid.

[58] Ibid., 137.

[59] Ibid., 132.

[60] Ibid., 138.

[61] Ibid.

[62] Ibid.

[63] Ibid., 135.

[64] Ibid., 144.

[65] Ibid., 143.

[66] Ibid., 144.

[67] French Painting, Chardin to Derain, 17.

[68] Ibid., 19.

[69] Louis Vauxcelles, quoted in Pierre Courthion, *Georges Rouault* (New York: Harry N. Abrams,1961), 106.

[70] Quoted in James Thrall Soby, *Georges Rouault, Paintings and Prints* (New York: The Museum of Modern Art, 1945), 6.

[71] Ibid., 28.

[72] Bernard Dorival and Isabelle Rouault, *Oeuvre Rouault Peint*, 2 vols. (Monte Carlo: Editions André Sauret, 1988), v. 1, 183.

[73] Quoted in Dorival and Rouault, v. 1, 40. I would like to thank Andrea Vagianos for her research on Rouault at The Phillips Collection.

[74] Rouault to André Suarés, Letter 46, 23 October 1913, in *Georges Rouault-André Suarés Correspondence 1911-1939*, trans. Alice B. Low-Beer (Devon, 1983), 49.

[75] "The Modern Argument in Art and Its Answer," 49.

[76] Ibid.

[77] "Modern Wit in Two Dimensional Design," *A Bulletin of the Phillips Memorial Gallery Containing Notes of Interpretation Relating to the Various Exhibition Units* (October 1931-January 1932),19.

[78] Ibid., 21.

[79] "The Functions of Color in Painting, An Educational Loan Exhibition," exhibition booklet (Washington, D.C.: Phillips Memorial Gallery, 1941), 30.

[80] "Rouault in America, 1940-41," in *A Bulletin of the Phillips Memorial Gallery*, January 1941, n.p.

[81] DP to Valentine Dudensing, 12 June 1944 (TPC Papers, Archives of American Art).

[82] Duncan Phillips, *Soutine*, exhibition catalogue (Washington, D.C.: Phillips Memorial Gallery,1943), n.p.

[83] See the reminiscences of Soutine's companion during this time, Mlle. Garde [Gerda Groth], *Mes années avec Soutine*, ed. Jacques Suffel (Paris: Les lettres nouvelle, 1973), 75-76. I am indebted to Leslie Furth's insightful research into firsthand accounts of Soutine during this period.

[84] For the identification of the sitter and the painting's quick execution, see Ibid., 53.

[85] "Modern Art and the Museum," *The American Magazine of Art* 22 (February 1931), 273.

[86] Quoted by Albert E. Gallatin in Philadelphia Museum of Art, *A. E. Gallatin Collection, "Museum of Living Art,"* exhibition catalogue, (Philadelphia, 1954), 6.

[87] "Leaders of French Art Today."

[88] C. M. de Hauke to DP, 17 October 1930 (TPC Papers, Archives of American Art).

[89] DP to de Hauke, 25 October 1930 (TPC Papers, Archives of American Art).

[90] Laurie Eglington, "Paul Rosenberg, Now in New York, Comments on Art," *Art News* (December 2, 1933), 1,4.

[91] See Laurie Eglington, "Braque, Matisse and Picasso Exhibited: Mr. Paul Rosenberg Brings to the Durand-Ruel Galleries His Renowned Abstractions and Early Matisses," *Art News* (March 17, 1934), 1,4-6.

[92] Bill of sale, 21 January 1925 (Paul Rosenberg Papers, Pierpont Morgan Library). For Gallatin's acquisition of the painting see Susan C. Larsen, "Albert Gallatin: The 'Park Avenue Cubist' who went downtown," *Art News* 77 (December 1978), 80-82.

[93] Alfred Barr to Albert E. Gallatin, 26 September 1936, quoted in Debra Bricker Balken, *Albert Eugene Gallatin and His Circle* (Coral Gables, Florida: Lowe Art Museum, 1986), 26.

[94] DP to LV, 1 February 1949 (TPC Papers, Archives of American Art).

[95] "The Artist's Choice: Bonnard," in *The Artist Sees Differently; Essays Based Upon the Philosophy of a Collection in the Making*" (New York: E. Weyhe, 1931), 128, 125.

[96] "Georges Braque," pamphlet, (New York: The Twin Editions, 1945).

[97] "Art: World's Greatest in a New York Basement," *New York Times*, 9 December 1983.

[98] Marjorie Phillips, 178.

[99] Quoted in Antoine Terrasse, "Bonnard's notes," *Bonnard: The Late Paintings* (Washington, D.C.: The Phillips Collection, 1984), 70.

Chaim Soutine, *Return from School After the Storm* (1939) oil on canvas, 17 x 19-1/2 in.

Duncan Phillips and the School of Paris: Chronology of Acquisitions, Exhibitions and Writings

Compiled by Caroline Cassells and Elizabeth Chew, with the assistance of Genevieve Wheeler

1911

Spring: Duncan Phillips (b. 1886) leaves on a trip to Europe, which he spent "motoring and studying paintings throughout Belgium, Holland, Germany, and France" (according to Yale College's *History of the Class of 1908*).

1912

Spring: Phillips goes again to Europe, "this time with art study as my single purpose" (Yale class history). In Paris, he visits the Louvre and the apartment of Paul Durand-Ruel, the Musée du Luxembourg and many other museums, galleries, and artists.

1913

The Association of American Painters and Sculptors presents the Armory Show in New York City.

1914

Phillips responds to the Armory Show in an article entitled, "Revolutions and Reactions in Painting," published in his book of that year, *The Enchantment of Art*. He denounces European modernism and calls the show, "an International Exhibition of Modern Art quite stupefying in its vulgarity." He adds:

In the steady upward progress in this country to the great Renaissance that is surely coming we need none of this sensationalism, so recently imported from the old world.

1916

January 6: Phillips and his older brother, James Laughlin, write to their father about their interest in paintings and in collecting. They request a yearly stipend in the amount of $10,000 for the purchase of art. Their purchases reflect a particular interest in contemporary American painting.

1917

Sept 13: Major Phillips dies suddenly at Ebensburg, Pa.

1918

October 21: James Laughlin Phillips dies of the Spanish flu in Washington, D.C. Duncan Phillips and his mother decide to found the Phillips Memorial Art Gallery.

1919

Phillips compiles a handwritten list of the "15 best purchases of 1918-19." Contemporary American artists continue to (and will always) dominate the Collection. However, Phillips is also purchasing European works of the nineteenth century and before, including Chardin's *A Bowl of Plums* (ca. 1728).

May 25—June 5: Century Club, New York, holds an "Exhibition of Works Owned by Duncan Phillips."

1920

May: McKim, Mead, & White design a second skylit story over the north wing,

now the Music Room, of the Phillips home at 1600 21st St., NW. This addition becomes the Main Gallery once the museum opens.

July 23: Phillips Memorial Art Gallery is incorporated; by-laws are established.

Nov. 20—Dec. 20: The Century Club in New York shows 43 works in "Selected Paintings from the Phillips Memorial Art Gallery."

1921

January 2: *The Washington Star* prints the story, "Mrs. D.C. Phillips and Son Announce Intention of Establishing Phillips Memorial Gallery."

October 8: Duncan Phillips and Marjorie Acker are married in Ossining, New York.

Late fall: Phillips Memorial Art Gallery quietly opens to the public, probably with admission by appointment.

1922

Phillips publishes *Honore Daumier: Appreciations of His Life and Works.* Between 1920 and 1953, he acquires 57 paintings, drawings and prints by this artist.

January 3: Duncan Phillips announces the new exhibition season and regular visiting hours in three letters to Washington newspapers:

The Phillips Memorial Art Gallery, 1608 21st Street, Northwest, after many delays, will open to the public from February 1st to June 1st on Tuesday, Thursday, and Saturday afternoon.

December 5: The winter season begins with Gallery hours from two to five Tuesdays, Saturdays and Sundays.

1923

June 6: Duncan and Marjorie Phillips sail from New York for a two months' stay in Europe. They view Renoir's *The Luncheon of the Boating Party* during lunch at the home of art dealer Joseph Durand-Ruel. Phillips purchases the painting, which is later shipped to the U.S. In a letter to Dwight Clark dated July 10, Phillips writes:

The big Renoir deal has gone through with Durand-Ruel and the Phillips Memorial Gallery is to be the the possessor of one of the greatest paintings in the world Its fame is tremendous and people will travel thousands of miles to our house to see it. It will do more good in arousing interest and support for our project than all the rest of our collection put together.

December: The fall season opens, with a new hanging of the permanent collection featuring the Renoir.

December 20: Phillips requests publicity for the purchase of *The Luncheon of the Boating Party* in letter to Guy Pène du Bois at *International Studio*:

I could get lesser examples which would give great satisfaction, but for such an American Prado as I am planning, there must be nothing but the best.

December 30: *The Sunday Star* describes the circumstances of the acquisition, including that the work was shown at the New York branch of Durand-Ruel the year before, during which time all offers to buy it were refused:

The owner having decided that if they ever allowed it to leave France, it would have to go to a museum.

1924

April: A permit is issued to change the Gallery entrance; a new door at 1608-21st allows the public direct access via an elevator to the Main Gallery.

July: John Quinn, an important collector of contemporary art, dies. The dispersal of his collection sparks debate over the need for an American museum of modern art. Prominent critics, collectors and artists join the discussion. Arthur B. Davies, American artist and one of the organizers of the Armory show, even suggests to Lillie Bliss and Mrs. Cornelius J. Sullivan that a museum of modern art be founded with the Quinn collection as its nucleus.

1925

Early January: An exhibition of recent work by Marjorie Phillips inaugurates the Little Gallery, adjacent to the Main Gallery. Phillips will use this space mainly for small exhibitions of work by American artists.

Fall: Phillips sees Pierre Bonnard's *Woman with Dog* (1922) at Pittsburgh's Carnegie International (October 15—December 6). Soon thereafter, he acquires this, his first School of Paris work, as well as another Bonnard, *Early Spring* (1908), from Bernheim Jeune and Co., Paris. They are the first of 30 works by Bonnard to enter the permanent collection.

December 1: Duncan Phillips writes to Leila Mechlin about his plans for the Little Gallery:

I feel that Washington will not know at this time what is taking place in contemporary painting unless I show in our Little Gallery the work of some very original men who are reaching out in new directions. Therefore I am planning little by little through a series of group exhibitions to suggest current tendencies which I consider rational and interesting.

Other Notable Acquisitions

Emile-Antoine Bourdelle, *Virgin of Alsace* (1920); acquired from C. W. Kraushaar, New York

1926

Phillips publishes *A Collection in the Making; A Survey of the Problems Involved in Collecting Pictures Together With Brief Estimates of the Painters in the Phillips Memorial Gallery.*

January: The Art Center in New York City has a memorial exhibition of selected works from the collection of the late John Quinn.

October 23: The *Art News* reports from Paris:

The great event of the season, that which causes a commotion in the rue de la Boëtie, is the sale [at the Hotel Drouot] . . . of the collection of John Quinn . . . which contains beside a series of water colors by Rouault, works by Cézanne, Derain, Sagonzac [sic], Picasso, Odilon Redon, Juan Gris, Dufy, Laurencin, etc.

May 8-30: Phillips has an Exhibition of "Intimate Impressionists" which includes *Early Spring* and *Woman with Dog* by Bonnard.

September: Bonnard visits the museum and meets the Phillipses while serving

Pierre Bonnard in his Atelier (Courtesy of Roger-Viollet, Paris)

on the jury for the Carnegie International. Phillips would later remember in a letter to Mrs. Charolette Devree dated November 30, 1954:

We were immediately attracted to Bonnard the man and our meeting was followed by an exchange of letters. We were glad to have him see that we had already purchased two of his best pictures Early Spring and Woman and Dog.

November 1926 to January 1927: Phillips purchases Henri Matisse's *Girl in Chair* and *Anemones* from F. Valentine Dudensing, New York. Although both paintings will be traded for another Matisse at the end of 1927, Phillips ultimately acquires five works by Matisse for the permanent collection. In a letter to Duncan Phillips dated January 10, 1927, F. Valentine Dudensing writes:

I certainly am pleased that you get [sic] this picture and I know that Monsieur Matisse accepted because it is going into such fine company with the works you already have.

1927

January 10: First correspondence with Alfred Barr, scholar of modern art and soon to be founding Director of the Museum of Modern Art, New York. In the spring of 1927, Barr will teach two art history courses at Wellesley College, including a ground breaking survey of contemporary art. He asks Phillips to help him with this important project, saying:

Are we not both experimenting in the same problem, though you are far advanced where I am just beginning.

Barr reviews Phillips's *A Collection in the Making* in the Saturday Review of Literature the following September. He calls the book

the record of enthusiasm for an ideal, of a generous and in the best sense public-spirited ambition In the reviewer's estimation it is the most comprehensive and valuable anthology of the last fifty years of American painting thus far produced.

February 5—April: The first of five Tri-Unit exhibitions is installed in the Lower, Little and Main Galleries. The Main Gallery features "Sensibility and Simplification in Ancient Sculpture and Contemporary Painting," which includes work by Bonnard and Matisse. Phillips writes Barr, urging him to come to Washington to see the show.

Spring: Phillips purchases Braque's *Plums, Pears, Nuts and Knife* (1926) from Durand-Ruel, New York. It is the first of 14 works by this artist to enter the permanent collection. In a letter to Joseph Durand-Ruel dated April 15, Phillips writes:

I would like to have a Braque and one of those two narrow canvases, the one with the knife and the fruits, 8 x 28, might be reserved for me if you feel inclined to take a chance on my liking it enough.

Fall: Phillips purchases two paintings by André Derain, *Southern France* (1927) from the Henry Reinhardt and Son Galleries, New York and *Head of a Woman* from C. W. Kraushaar, New York. They are the first of five works by this artist to enter the permanent collection. Of the landscape, he writes to Dwight Clark on November 14:

It takes its place in the great tradition of French painting and is really as fine as a Courbet or even a Corot in design and quality He is a living artist of middle age and is considered the best of living painters by many good judges.

Fall: Phillips purchases Picasso's *The Blue Room* (1901), formerly *La Toilette*, from Wildenstein and Co., New York. It is the first of ten works by this artist to enter the permanent collection.

November—December: Phillips returns Matisse's *Anemones* (1923) and *Girl in Chair* (n.d.) to F. Valentine Dudensing in an even trade for Matisse's *Anemones with a Black Mirror* (1919).

December 3, 1927—January 31, 1928: Phillips Memorial Gallery presents "Leaders of French Art To-Day: Exhibition of Characteristic Works by Matisse, Picasso, Braque, Segonzac, Bonnard, Vuillard, Derain, André, Maillol."

December 12: The Gallery of Living Art, founded by Albert Eugene Gallatin, opens at New York University. The opening exhibition is drawn mainly from Gallatin's personal collection of contemporary art, including works by Braque, Cézanne, Chagall, de Chirico, Dufy, Gris, Léger and Picasso.

Other Notable Acquisitions

Pierre Bonnard, *Children and Cat* (1909); acquired from F. Valentine Dudensing, New York

Pierre Bonnard, *Grape Harvest* (1926); acquired from De Hauke & Co., New York

Pierre Bonnard, *Interior with Boy* (1910); acquired from F. Valentine Dudensing, New York

Pierre Bonnard, *The Lesson* (1926); acquired from F. Valentine Dudensing, New York

Pierre Bonnard, *Woods in Summer* (1927); acquired from F. Valentine Dudensing, New York

Pierre Bonnard, *Le Moulin Rouge*, (n.d.); acquired from De Hauke & Co., New York; later deaccessioned

Henri Matisse, *A Path at Nice*, (n.d.); acquired from C. W. Kraushaar, New York; later deaccessioned

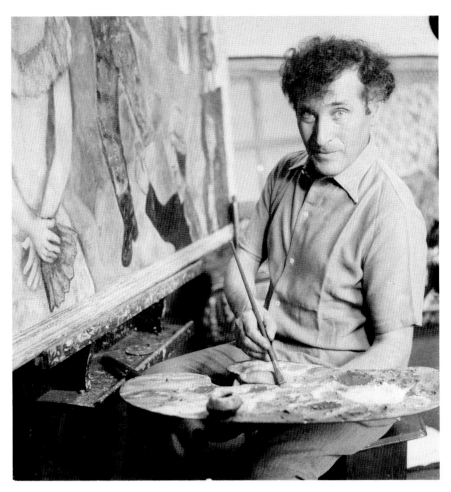

Marc Chagall in his Studio (August 1934)
(Courtesy of Roger Viollet, Paris)

Henri Matisee, *Woman at the Window* (n.d.); purchased from F. Valentine Dudensing in April; traded back for a Derain *Still Life* in November

1929

October 25: Phillips elected to MOMA board of trustees.

November 8: The Museum of Modern Art opens in New York with Alfred Barr as its director. Their first exhibition is "Cézanne, Gauguin, Seurat." Phillips lends Cézanne's *Self Portrait* (1878-80).

Other Notable Acquisitions

Georges Braque, *Lemons, Peaches and Compotier* (1927); acquired from Henry Reinhardt and Son, New York

Georges Braque, *Pitcher, Pipe and Pear* (ca. 1924); acquired from C. W. Kraushaar, New York

Georges Braque, *Still Life* (silkscreen) (n.d.); originally purchased from C. W. Kraushaar, New York; gift to the Collection from Marjorie Phillips, 1985

Giorgio de Chirico, *Horses* (n.d.); acquired from F. Valentine Dudensing, New York

André Derain, *Ballet Dancer* (n.d.); aquired from Wildenstein and Co., New York; later deaccessioned

André Derain, *Road Through the Woods* (n.d.); later deaccessioned

André Derain, *Still Life with Pears and Grapes* (small) (n.d.); later deaccessioned

André Derain, *Tête Brune* (n.d.); later deaccessioned

Pablo Picasso, *Abstraction, Biarritz* (1918); acquired from F. Valentine Dudensing, New York

1930

January 18—March 22: The Museum of Modern Art has its third exhibition, "Paintings in Paris." Phillips lends Bonnard's *Interior with Boy* (1910), *The Palm* 1926, *Riviera* (ca. 1923) and *Woman with Dog* (1922), Braque's *Plums, Pears, Nuts and Knife* (1926), Derain's *Mano, the Dancer* (1928) and *Southern France* (1927), and Picasso's *Abstraction Biarritz* (1918).

1928

February—May: The Gallery presents its second "Tri-Unit Exhibition of Paintings and Sculpture" with an installation of "A Survey of French Painting from Chardin to Derain" in the Lower Gallery.

March 16—31: De Hauke and Co. have a retrospective exhibition of Pierre Bonnard. Phillips lends *Le Moulin Rouge, Early Spring* (1908) and *Woman with Dog* (1922). In a letter to C. M. De Hauke dated February 11, Phillips writes:

It is always a sacrifice to allow any of our very finest things to leave the house. I would do so in this case in the pride of seeing this picture alongside the other Bonnard masterpieces from Paris.

March: Phillips purchases Bonnard's *The Palm* (1926) and *The Riviera* (ca. 1923) from De Hauke.

October: Phillips acquires André Derain's *Mano, the Dancer* (1928) from De Hauke and Co., New York. The Art News applauds the purchase and heralds the painting as "one of the outstanding works of our time" (The Art News, November 10, 1928).

Other Notable Acquisitions

André Derain, *Still Life With Grapes* (n.d.); acquired from F. Valentine Dudensing, New York; later deaccessioned

Charles Despiau, *Head of Madame Derain* (plaster) (1922); acquired from The Brummer Gallery, New York

Fall: The Phillips family moves to a new house at 2101 Foxhall Road, N.W. A press release announces the expansion of the Gallery into the former residence:

A new museum of Art for Washington opens in October 5 The first two floors of the former residence of Mr. and Mrs. Duncan Phillips have been made ready for changing exhibits and eight rooms converted into new picture galleries In three bedrooms on the second floor paintings have hung, each room representing an intimate exhibition of modern art. On the top floor study rooms and studios will ultimately be equipped.

Fall: Phillips purchases Dufy's *Polo* (ca. 1930) from F. Valentine Dudensing. It is the first of ten works by this artist to enter the permanent collection.

Fall: Phillips purchases Bonnard's *The Open Window* (1921) from Jacques Seligmann & Co. In a letter to Phillips dated October 17, C. M. de Hauke writes:

The efforts of our correspondent have been very successful and have influenced the owner of "La Fenêtre Ouverte" by BONNARD, to consent parting with it, at a price which I consider extremely attractive. This enables us, if such is your desire, to conclude the sale of the picture to your collection, for $11,000.

September: Henri Matisse visits the Gallery while in the United States as a juror for the Carnegie International Exhibition. The Phillipses are invited to dine with the artist.

October: Phillips trades André Derain's *Ballet Dancer* (n.d.) to Wildenstein and Co., as partial payment for Vincent Van Gogh's *Public Gardens at Arles* (1888).

Winter: Phillips acquires Juan Gris's *Abstraction* (1915) from André Salmon, through John Graham. It is the first of two works by this artist to enter the permanent collection. In a letter to Phillips dated December 3, 1929, Graham writes:

Gris is very scarce on the marcket [sic] and prices are rapidly going up, and in [sic] couple of years it will be like Modigliani

Man Ray, *Matisse* (1922) (Courtesy of Man Ray Trust © 1991 ARS NY/ADAGP)

now. Rosenberg told me that he had 246 paintings by Gris and has now but one left.

December 13: Phillips trades three paintings by Derain, *Road through the Woods* (n.d.), *Still Life with Pears and Grapes* (small) (n.d.), and *Tête Brune* (n.d.) to F. Valentine Dudensing for Henri Rousseau's *Notre Dame* (1909). In a letter to Dudensing dated December 3, Phillips writes:

I have thought of the Derain <u>Decorative Landscape</u>, of 1901, the Derain <u>Road through the Woods,</u> and the Segonzac River Scene (photographs enclosed), but all these are great treasures it would be folly to part with. If I must I suppose I can for the little Rousseau warms the heart in a remarkable way and makes itself necessary.

Other Notable Acquisitions

Pierre Bonnard, *The Open Window* (1921); acquired from Jacques Seligmann & Co., New York by 1930

Georges Braque, *Still Life with Grapes and Clarinet* (1927); acquired from Henry Reinhardt & Son, New York

André Derain, *Decorative Landscape* (1900); acquired from F. Valentine Dudensing, New York; later deaccessioned

Max Jacob, *Christ Stilling The Tempest* (1928); acquired by 1930

Pablo Picasso, *Studio Corner* (1921); acquired from F. Valentine Dudensing, New York

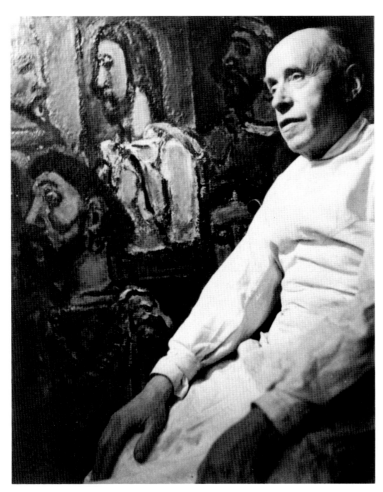

Yvonne Chevalier, *Georges Rouault* (1943)
(Courtesy of the Musée National d'Art
Moderne)

1931

Phillips publishes *The Artist Sees Differently; Essays Based Upon the Philosophy of a Collection in the Making.*

January: Phillips purchases Rouault's *Tragic Landscape* from Kraushaar. It is the first of twenty-six works by this artist to enter the permanent collection.

November 3—December 6: The Museum of Modern Art has a retrospective exhibition of the work of Henri Matisse. Matisse's *Studio, Quai St. Michel* (1916), later purchased by Phillips, is included in the show.

Other Notable Acquisitions

Pierre Bonnard, *Movement of the Street* (ca. 1907); acquired from De Hauke & Co., New York

Georges Braque, *Lemons and Napkin Ring* (1928); acquired from F. Valentine Dudensing, New York

Louis Marcoussis, *Abstraction* (1930); acquired from the Balzac Galleries, New York

Louis Marcoussis, *Abstraction (Pink and Gray)* (1930); later deaccessioned

1932

Summer: The Phillips family sets out for Europe on the first of three "Giorgione trips" as part of Phillips's research on this Italian Renaissance artist, which eventually leads to a publication in 1937.

1933

July 10—September 30: The Museum of Modern Art holds its "Summer Exhibition: Painting and Sculpture." Phillips lends Bonnard's *Grape Harvest* (1926), *The Open Window* (1921), *The Riviera* (ca. 1923). The works remain in New York to be included in MOMA's fall exhibition, "Modern European Art."

December 24: The *New York Times* runs a story about an open letter from "a group of prominent artists and museum directors" to museums encouraging the purchase of works only by living artists in this time of depression.

From 1933—34, Phillips holds chairmanship of Regional Committee No. 4, Public Works of Art Project (PWAP; a branch of the WPA), covering the District of Columbia, Maryland, and Virginia. Law Watkins, Associate Director of The Phillips Memorial Gallery, chairs the District of Columbia Federal Art Project, which commissions artists to paint murals and pictures of "The American Scene."

Notable Acquisitions

Georges Rouault, *Landscape with Riders* (1930); acquired from C. W. Kraushaar

Georges Rouault, *Circus Trio* (1924); acquired from Pierre Matisse, New York

1934

March: Influential French art dealer, Paul Rosenberg, exhibits his private collection of modern French masterworks at Durand-Ruel Gallery in New York. Braque's *The Round Table* (*Le Guéridon*) (1929), Matisse's *Plaster Torso, Bouquet of Flowers* (1919) and one version of Picasso's *The Three Musicians* (1921) are among the works exhibited. This Picasso *Three Musicians* will eventually go to Alfred Barr and MOMA.

April 10: Phillips trades one of Claude Monet's *Melon and Fruit* (1880) and Henri Fantin-Latour's *Portrait of Sonia* (1890) to Paul Rosenberg for Matisse's *Plaster Torso, Bouquet of Flowers* (1919).

June: Phillips's acquires Braque's monumental *The Round Table* from Paul Rosenberg.

October 21: Phillips opens an exhibition in the Main Gallery entitled, "Cross Currents in Contemporary Painting." Braque's *The Round Table* is exhibited with works by Matisse, Picasso, Rouault and others.

December 29: Gertrude Stein delivers the lecture, "Pictures" at the Gallery. The lecture is not included in the published lectures of her U.S. speaking tour.

1935

Mid-June—late July: The Phillipses travel to Europe. While in Paris, they visit Bernheim Jeune and Co. and purchase Bonnard's *The Terrace*. It is shipped to Washington in early August. Phillips would later write that, "Of all our Bonnard [sic] only *The Terrace* was purchased in Paris" (Duncan Phillips to Mrs Charlotte Devree November 30, 1954).

1936

March 2—April 19: The Museum of Modern Art has a significant exhibition of "Cubism and Abstract Art."

Fall: Albert Gallatin acquires the other version of Picasso's *The Three Musicians* (1921) from the Mayor Gallery in London. This version also originally belonged to Paul Rosenberg. In an article in the October 31, 1936 issue of *Art News*, Gallatin writes:

Picasso has painted two famous versions of this subject, both of which are large in size and powerful in structure; they are generally accepted by critics all over the world as the two great masterpieces of modern painting The first version has been seen in New York at the Durand-Ruel Gallery and later at the Modern Museum.

Deaccessions

Henri Matisse, *A Path at Nice* (n.d.); traded in part to F. Valentine Dudensing for Eilshemius's *The Dream* (1936)

1937

November 1—20: Jacques Seligmann and Co., New York, exhibit Picasso's *Demoiselles d'Avignon* (1907). After two years of negotiations, Alfred Barr will acquire this painting for the Museum of Modern Art.

Notable Acquisitions

André Derain, *Head of a Young Woman* (n.d.); acquired from Theodore · Schempp, New York

Raoul Dufy, *Versailles* (ca. 1936); acquired from B. Raymond, New York

Pablo Picasso, *Bullfight* (1934); acquired from F. Valentine Dudensing, New York

Deaccessions

Andre Derain, *Still Life with Grapes* (n.d.); traded to F. Valentine Dudensing in exchange for Picasso's *Bullfight* (1934) and Eilshemius' *Park Avenue* (1937).

1938

January 27: Phillips gives a lecture (at the Gallery?), "The Expression of Personality Through Design in the Art of Painting." This lecture was repeated numerous times over the years based on eight versions, dated 1938-42.

September 28—November 18: The Museum of Modern Art has an exhibition of "The Prints of Georges Rouault."

Notable Acquisitions

Pierre Bonnard, *Narrow Street in Paris* (ca. 1897); acquired from Carroll Carstairs, New York

Pablo Picasso, *The Jester* (bronze) (1905); acquired from the Buchholz Gallery, New York

Georges Rouault, *Christ et les Pecheurs* (n.d.); acquired from Whyte Galleries, Washington; later deaccessioned

1939

By this year, the Phillips's exhibition program has extended to 25 shows and gallery hangings.

May 10—September 30: The Museum of Modern Art has an exhibition of *Art in Our Time: 10th Anniversary Exhibition*. Phillips generously lends Renoir's *The Luncheon of the Boating Party* (1881).

November 15—January 7: The Museum of Modern Art has a retrospective exhibition of "Picasso: Forty Years of His Art." Phillips lends several works, *The Blue Room* (1901), *Bullfight* (1934) and *The Jester* (1905).

December 6, 1939—January 6, 1940: The Gallery presents "Georges Braque: Retrospective Exhibition."

Notable Acquisitions

Raoul Dufy, *Chateau and Horses* (1930); acquired from Karl Nierendorf, New York

Raoul Dufy, *Epsom* (1935); acquired from Whyte Galleries, Washington

Raoul Dufy, *The Opera, Paris* (ca. 1924); acquired from Karl Nierendorf, New York

Raoul Dufy, *Harbour* (1939); acquired from Whyte Galleries, Washington; later deaccessioned

Georges Rouault, *Afterglow, Galilee* before (1930); acquired from F. Valentine Dudensing, New York

Georges Rouault, *Bouquet No. 1* (oil on metallic foil on paper mounted on cardboard) (ca. 1938); acquired from Pierre Matisse, New York

Georges Rouault, *Bouquet No. 2* (oil on newspaper) (ca. 1938); acquired from Pierre Matisse, New York

Georges Rouault, *Still Waters* (ca. 1937); acquired from Pierre Matisse, New York

Georges Rouault, *The Three Judges* (n.d.); acquired from J. B. Neumann's Gallery, New York; later deaccessioned

Georges Rouault, *Cirque de L'etoile filante*; book written and illustrated by Rouault; published by Ambrose Vollard, Paris (1938); acquired from Pierre Matisse, New York

Georges Rouault, Cirque de l'etoile filante (16 color etching & aquatint prints, hors texte) (1938)

1940

The February annual report of the National Gallery of Art lists Duncan Phillips as a trustee and member of the acquisition committee.

April 15—May 11, 1940: Carroll Carstairs has an exhibition entitled,

"Paintings by Soutine." Duncan Phillips will eventually acquire three works that were in this show, *Return from School After the Storm* (1939), *Woman in Profile* (1937), and *Windy Day, Auxerre* (1939).

Spring: Phillips buys Soutine's *Return from School After the Storm* (1939) from Carroll Carstairs. It is the first of four works by this artist to enter the permanent collection.

November: Phillips acquires Henri Matisse's *Studio, Quai St. Michel* (1916) from Pierre Matisse. The December 29th issue of *The Washington Post* reports on the acquisition:

At the present time several of the new French acquisitions are on view in the gallery. The important new Matisse, The Studio, is hanging on the staircase: the two new paintings by Cézanne, Fields— Bellevue, and the early, Harvesters, are on the first floor, as well as the newly acquired Degas, the superb Women Combing Their Hair, and a small Seurat.

December 15: "Georges Rouault: Retrospective Loan Exhibition" organized by James S. Plaut, director of Boston's Institute of Modern Art, opens at the Phillips.

Other Notable Acquisitions

Georges Braque, *Still Life with Pomogranate* (n.d.); acquired from the Bignou Gallery, New York; later deaccessioned

Raoul Dufy, *Hôtel Sube* (1926); acquired from Carroll Carstairs, New York

Raoul Dufy, *The Blue Window* (n.d.); acquired from F. Valentine Dudensing, New York; later deaccessioned

Raoul Dufy, *Joinville* (1938); acquired from the Bignou Gallery, New York

Raoul Dufy, *Seaside Motifs* (1928); acquired from the Whyte Gallery, Washington

Georges Rouault, *Christ and the High Priest* (ca. 1937); acquired from the Bignou Gallery, New York

Georges Rouault, *Self-Portrait* (litho) (n.d.); acquired from the Buchholz Gallery, New York

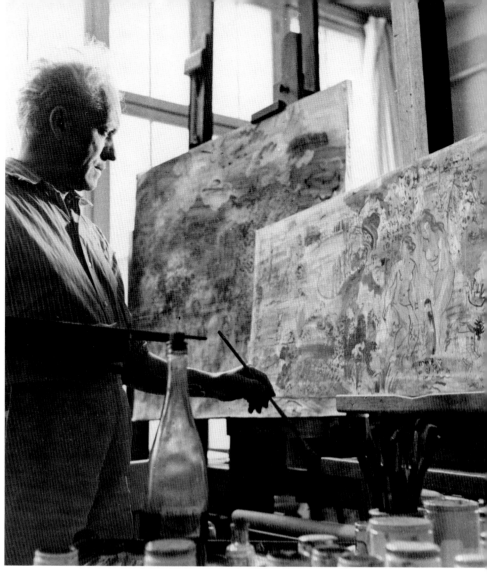

Roger Schell, *Raoul Dufy* (ca. 1937) (Courtesy of the Musée National d'Art Moderne)

Georges Rouault, *L'Ecuyere* (1937); acquired from the Bignou Gallery in exchange for Rouault's *Vase de Fleurs*

Deaccessions

Georges Rouault, *The Three Judges* (n.d.); traded to Bignou Gallery for Rouault's *Bouquet de Fleurs* (1932)

Georges Rouault, *Bouquet de Fleurs* (1932); acquired from Bignou through trade for Rouault's *The Three Judges* (n.d.)

Raoul Dufy, *Harbour* (1939); traded to Bignou for Dufy's *Joinville* (1938)

1941

January: Pierre Matisse holds an exhibition of "Landmarks of Modern Art." Phillips lends Matisse's *Studio, Quai St. Michel.*

Phillips publishes "Rouault in America, 1940-41," in *A Bulletin of the Phillips Memorial Gallery*, January 1941.

March 31: At the opening of Marjorie's exhibition at New York's Bignou Gallery, Marjorie and Duncan Phillips meet Katherine Dreier, collector of modern art and founder, with Marcel Duchamp and Man Ray of the *Societé Anonyme*. It is the beginning of several years of intermittent correspondence.

March 17: The new building of the National Gallery of Art, designed by John Russell Pope, opens to the public.

June: Phillips buys Daumier's *Advice to a Young Artist* (after 1860), intending to give it to the National Gallery. Hoping that the NGA committee will accept the gift, he writes to the Bignou Gallery, New York:

I am most anxious to help the National Gallery with this picture to build a bridge in its collection between the Old Masters and the Moderns. With such an artist they can go on to bolder and freer uses of color and form in the 19th century.

June: Phillips trades three works by School of Paris artists—Rouault's *Landscape with Riders* (1930), Dufy's *The Blue Window* (n.d.) and Braque's *Still Life with Pomogranate* (n.d.)—to the Bignou Gallery as partial payment for Degas' *La Loge* (ca. 1874) (also called *Reflection* or *Melancholy*). He also consigns another painting, Bonnard's *Le Moulin Rouge* (n.d.) to be sold and the money put toward the Degas purchase.

July 16—September 7: The Museum of Modern Art has an exhibition of "Masterpieces of Picasso."

November 3—December 6, 1941: Picasso's *The Three Musicians* is on loan to the Phillips Collection from Rosenberg in exchange for *The Luncheon of the Boating Party*, which was needed for his Renoir retrospective. This version of the painting will be purchased by MOMA in 1949 (see below). An article in the November 23 issue of *The Washington Post* reports:

To it has been given the place of honor in the main gallery, and with it are set forth a number of paintings from the Phillips collection by artists, chiefly French, who likewise but diversely, find expression through the use of the modern idioms.

Other Notable Acquisitions

Georges Braque, *Lemons and Oysters* (1927); acquired from the Buchholz Gallery, New York

Pablo Picasso, *L'Abreuvoir* (drypoint/ paper) (1905); acquired from the Buchholz Gallery, New York

Pablo Picasso, *La Coiffure* (litho) (1923); acquired from the Buchholz Gallery, New York; traded 1933; reacquired 1941

1942

February: Phillips trades Matisse's *Plaster Torso, Bouquet of Flowers* (1919), to Paul Rosenberg for Corot's *View from the Farnese Gardens, Rome* (1826). In a letter

to Paul Gilbert at the Colorado Springs Art Center dated February 12, Phillips writes:

I have long wanted an example of the early period of Corot and of the paintings he did on his early trips to Italy. Such a picture has turned up and the only way I can pay for it is to give up a fine modern painting which has been sent to you, namely, the Plaster Torso *by Henri Matisse.*

Fall: Phillips purchases Marc Chagall's *The Dream* (1939) and *The Village Street* (1937-40), from Pierre Matisse. *The Village Street* will later be traded for another Chagall, *La Ville*, which will also be traded. Thus, *The Dream* is the only Chagall to enter the permanent collection.

December: The Chancellor of New York University forces the closure of Gallatin's Museum of Living Art, citing the need for space for a library processing center.

Notable Acquisitions

Georges Rouault, *Christ and the Poor* (before 1939); acquired from the Bignou Gallery, New York; later deaccessioned

Deaccessions

Georges Rouault, *Christ et les pecheurs*, (n.d.); traded to the Bignou Gallery as part payment for Rouault's *Christ and the Poor* (before 1939)

Georges Rouault, *L'Ecuyere* (1937); sent to the Bignou Gallery to be sold to finance the purchase of Rouault's *Christ and the Poor* (before 1939)

1943

A. E. Gallatin gives his collection to the Philadelphia Museum of Art.

January 17—February 15: Phillips presents the first U.S. museum exhibition for Chaim Soutine in the Main Gallery as part of "Six Loan Exhibitions;" with exhibition catalogue, "Soutine."

April: Phillips acquires two Soutines that were in the loan exhibition, *Windy Day, Auxerre* (1939), and *Woman in Profile* (1937) from Carroll Carstairs.

1944

Spring: Phillips acquires Dufy's *The Artist's Studio* (1935) from the Bignou Gallery. In a letter to Phillips dated May 20, Georges Keller at the Bignou Gallery writes:

If you really want the Dufy added to the Collection, and I know that the artist would like me to do all that I could to this end, would it be agreeable to you to buy it on installment?

June 25—October 18: Phillips holds an exhibition of "Paintings by Raoul Dufy," in two of the smaller galleries. The show includes, *The Artist's Studio* (1935).

December: Duncan Phillips trades a Chagall, *The Village Street* (1937-40) to Pierre Matisse for another Chagall, *La Ville*. In a letter to Pierre Matisse dated December 18, Phillips writes:

I should have written to you immediately upon our return from New York confirming what I told you when Mrs. Phillips and I called at your Chagall exhibition on our way to the station, namely that we would take the painting of the artist at his easel attended by faces from the dead past in Russia in an uneven exchange for the painting Village Street *by the same artist which we had left to be sold for our account.*

December 30: Phillips responds to a request from Alfred Barr about the Phillips's Picasso holdings. Throughout his career as a collector of contemporary European art, Phillips hoped to acquire a monumental work by Picasso. Marjorie Phillips later recalled how much he would have liked to acquire MOMA's version of *The Three Musicians*. In this letter, he reflects upon this ongoing dilemma:

Forgive my delay in answering your letter in which you asked me whether we had added to our all too-unrepresentative a collection of the great Picasso. No, I regret to say that I have been unable to purchase one or two important oils which I tried to get from their owners and we still have only the works you mention, namely, the Blue Room *1901, often known as* The Tub *and* Early Morning, Abstraction *1918,* Studio Corner *1921, a watercolor,* Bull Fight *1934, and the bronze* The Jester *1905. We have quite a few of his etchings and lithographs but no drawings.*

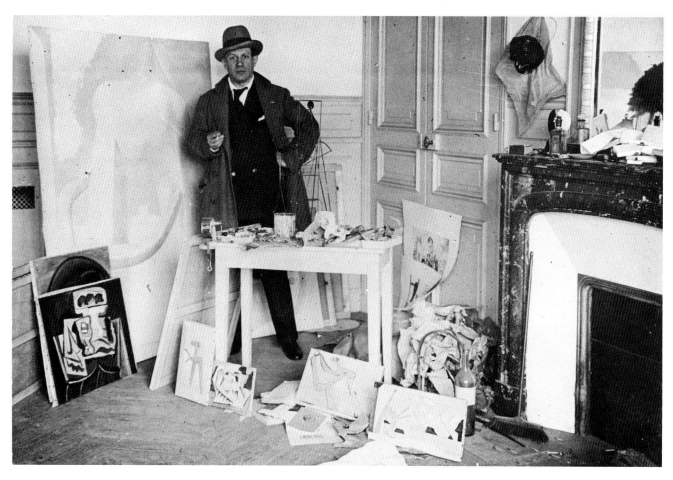

Picasso in his Atelier (1929) (Courtesy of Roger Viollet, Paris)

1945

April 4—June 3: The Museum of Modern Art has a Georges Rouault exhibition. Phillips lends *Afterglow, Galilee* (before 1930) and *The Circus Trio* (1924).

1946

Notable Acquisition

Henri Matisse, *Danseuse* (1926); acquired from Durand-Ruel, New York

1947

January—February 1947: Phillips trades Matisse's *Anemones with a Black Mirror* (1919), Matisse's *Danseuse* (n.d.), Chagall's *La Ville* (n.d.), and Rouault's *Christ and the Poor* (before 1939) to Pierre Matisse for Rouault's magnificent portrait of *Verlaine* (ca. 1939). In a letter

to Pierre Matisse dated January 27, Phillips writes:

The Rouault Portrait of Verlaine *arrived safely and we do want to keep it with us where we feel it belongs.*

Phillips contributes "Georges Rouault" to *Right Angle* 1 (May 1947): 4-5.

July 24: Phillips is named an Officer of the French Legion of Honor in a letter from the French Embassy. (The official ceremony takes place on November 3.)

Other Notable Acquisitions

Pierre Bonnard, *Circus Rider* (1894); acquired from Theodore Schempp, New York

Pablo Picasso, *Bullfight* (litho) (1946); acquired from the Buchholz Gallery, New York

1948

May 10—September 6: The Museum of Modern Art has an exhibition of the work of "Pierre Bonnard." Phillips lends *The Palm* (1926) and *The Riviera* (ca. 1923).

October 14: The Phillips Memorial Gallery becomes known officially as The Phillips Gallery.

Acquisition

Georges Braque, *The Washstand* (1944); acquired from Paul Rosenberg, Paris

1949

Mrs. Simon Guggenheim provides funds for The Museum of Modern Art to acquire Picasso's *Three Musicians* (1921) from Paul Rosenberg.

February: Henri Matisse's *Egyptian Curtain* (1948) has its first showing in this country at the Pierre Matisse Gallery.

March 29—June 12: The Museum of Modern Art has an exhibition of works by "Georges Braque." Phillips lends *Still Life with Grapes and Clarinet* (1927) and *The Round Table* (1929).

June—September: Matisse's *Egyptian Curtain* (1948) is included in an exhibition of Paintings by Henri Matisse at the Musée d'Art Moderne, Paris.

"Pierre Bonnard." *The Kenyon Review* 11 (Autumn 1949): 561-66.

November: Pierre Matisse includes *Egyptian Curtain* (1948) in his exhibition of "Selections 1949."

November—December: Phillips begins negotiations with Pierre Matisse for Henri Matisse's *Egyptian Curtain* (1948). In a letter to Pierre Matisse dated December 6, Phillips writes:

It is a pity to miss such an opportunity to complete the representation of my father's work with this painting which alongside the magnificent Studio would make a perfect showing I want to assure you that I would do all I could to make this accession to your collection possible, and I know that the artist himself would have every consideration if he knew that you were interested in the painting and wished to include it in your collection.

December: Phillips purchases Modigliani's *Elena Povolozky* from the Pierre Matisse Gallery, New York. Although two Modigliani drawings were given to the Collection in 1943, this is the only Modigliani Phillips will purchase. In a letter to Phillips dated December 9, Pierre Matisse writes:

It is almost impossible to find Modigliani's of this quality on the market anywhere and with the Museum of Modern Art's one man show of the artist's works scheduled for next fall the demand for these pictures is increasing rapidly.

1950

Notable Acquisitions

Juan Gris, *Still Life with Newspaper* (1916); acquired from Katherine Dreier through Marcel Duchamp

Henri Matisse, *Interior with Egyptian Curtain* (1948); acquired from the artist through Pierre Matisse, New York

Pablo Picasso, *Woman's Head* (litho) (1945); acquired from George Binet, New York

Pablo Picasso, *Seated Woman* (1924); originally acquired in 1950; gift to the Collection from Marjorie Phillips, 1984

Chaim Soutine, *The Pheasant* (1926-27); acquired from Pierre Matissse, New York

1951

October 31—January 7: The Museum of Modern Art has a Chaim Soutine exhibition. Phillips lends *Windy Day, Auxerre* (1939), *Woman in Profile* (1937) and *Return from School After the Storm* (1939).

Notable Acquisitions

Pierre Bonnard, *Landscape with Mountain* (1924); acquired from Theodore Schempp, New York

1952

February 10: Clive Bell speaks at the Gallery on Bonnard.

March 29: Katherine S. Dreier dies in Millford, Conn.; she leaves part of her private collection for dispersal by executors. Marcel Duchamp visits Washington in May to announce that The Phillips Gallery is to enjoy part of this bequest. Phillips chooses 17 works by Klee, Braque, Mondrian, Kandinsky, et al. Duchamp's *Small Glass* goes to the Museum of Modern Art at Alfred Barr's urging, though originally offered to the Gallery. Phillips sends 14 other works to The American University's fledgling Watkins Gallery.

Phillips publishes the first comprehensive catalog of his collection, *The Phillips Collection; A Museum of Modern Art and Its Sources; Catalogue.* Phillips writes in reference to the subtitle of this book that it has

never been accurately descriptive. We are not exclusively modern. In fact, the first impression on entering is apt to be decidedly un-modern Our sources of twentieth-century painting are great painters from the late fifteenth century up to the portals opening on today and tomorrow. Our modernists, in other words, our heroes of evolutionary progress in art, include Giorgione, El Greco, Chardin, Goya.

Acquisitions

Pierre Bonnard, *Nude in an Interior* (ca. 1935); acquired from the Sidney Janis Gallery

Deaccession

Louis Marcoussis, *Abstraction (Pink and Gray)* (1930); given to American University

1953

March 31—May 31: The Museum of Modern Art has another Rouault exhibition. Phillips lends *Afterglow, Galilee* (before 1930) and *Verlaine* (ca. 1939).

November 27: Noted French art historian Germain Bazin speaks at the Phillips on "Tradition and Revolution in French Art."

Notable Acquisitions

Georges Braque, *The Philodendron* (1952); acquired from Theodore Schempp, New York

Georges Braque, *The Shower* (1952); acquired from Theodore Schempp, New York

Gifts from the estate of Katherine S. Dreier:

Raymond Duchamp-Villon, *Gallic Cock* (relief) (1916)

Louis Marcoussis, *Painting on Glass, No. 17* (1920)

Deaccessions

André Derain, *Decorative Landscape* (n.d.); consigned to M. Knoedler and Co., New York; bought by Knoedler in the same month

Despiau in his Atelier (Courtesy of Roger-Viollet, Paris)

1965

January 12: Duncan Phillips is named a Fellow for Life of the Metropolitan Museum of Art.

January 26: Duncan Phillips writes "A Statement of My Wish for the Future of the Phillips Collection," printed in Marjorie Phillips's *Duncan Phillips and His Collection.*

1966

May 9: After having supervised the installation of works by American Master Arthur Dove, Duncan Phillips falls ill and dies of a heart attack at his Washington, D.C. home. Marjorie Phillips takes on the directorship of the Collection.

Acquisition

Georges Braque, *Bird* (1956); acquired from Knoedler and Co., New York

1954

February 24: Phillips speaks on "The Pleasures of an Intimate Art Gallery" in a WCFM radio program. The manuscript is also used as Gallery handout under the title, "Catholicity Does Not Mean Eclecticism."

November 30: In a letter to Charlotte Devree, Phillips reflects upon his method of collecting:

You asked how often we have been to Europe and what pictures we purchased there. I went overseas annually for awhile but have not left this country for a long time. I am proud to have acquired most of the treasures in New York, that greatest of art centers.

1958

April 8—April 15 and May 12—June 1: The Museum of Modern Art has an exhibition of works by Juan Gris. Phillips lends *Still Life with Newspaper* (1916).

1959

Phillips is unanimously elected by the Friends of the Whitney Museum of American Art to that museum's board of directors. He remains on the Board through 1965/66.

1960

November 5: The new wing of the museum opens to the public. Designed by the New York architect Frederick R. King of Wyeth and King, the annex at 1612-21st Street, NW., allows ample space for the permanent collection's key units, for temporary loan exhibitions, and for the display of sculpture. The Braque Unit is displayed downstairs. A review of the new building in The Sunday Star calls it a

small masterpiece of modern museum design and a rare example of a quiet brilliance in the installation of art for public view.

1961

André Malraux, French minister of cultural affairs, writer and art historian, tours The Phillips Gallery and the new annex.

July 11: The Phillips Gallery is renamed The Phillips Collection.

Marc Vaux, *Amedeo Modigliani* (before 1919) (Courtesy of the Collection of Billy Klüver and Julie Martin)

Selected Bibliography

Apollinaire, Guillaume. *Apollinaire on Art: Essays and Reviews 1902-1918*. Breunig, Leroy, Ed. Trans. Susan Suleiman. New York: Da Capo Press, Inc., 1972.

"Artists in Captivity; Artists in Exile." *Art News* (November 1-14, 1941), 23-25.

Balken, Debra Bricker. *Albert Eugene Gallatin and His Circle*. Coral Gables, Florida: The Lowe Art Museum, 1986.

Barr, Alfred. *Painting in Paris from American Collections*. New York: The Museum of Modern Art, 1930.

Barr, Alfred. *Defining Modern Art: Selected Writings of Alfred H. Barr, Jr.* New York: Abrams, 1986.

Barr, Alfred. *Picasso; Fifty Years of His Art*. New York: The Museum of Modern Art, 1946.

Bellony-Rewald, Alice and Peppiatt, Michael. *Imaginations' Chamber: Artists and Their Studios*. Boston: Little, Brown and Company, 1982.

Bernadac, Marie-Laure. *Faces of Picasso*. Paris: Éditions de la Réunion des Musées Nationaux, 1991.

Cafritz, Robert, et al. *Georges Braque*. Washington, D.C.: The Phillips Collection, 1982.

Chipp, Herschel B. *Georges Braque: The Late Paintings*. Washington, D.C.: The Phillips Collection, 1982.

Cowart, Jack and Fourcade, Dominique. *Henri Matisse: The Early Years in Nice 1916-1930*. Washington, D.C.: National Gallery of Art, 1986.

Cowling, Elizabeth and Mundy, Jennifer. *On Classical Ground: Picasso, Léger, de Chirico and the New Classicism 1910-1930*. London: The Tate Gallery, 1990.

Dauberville, Jean and Henry. *Bonnard: Catalogue Raisonné de l'Oeuvre Peint*. 3 vols. Paris: Éditions Bernheim-Jeune, 1965.

Dorival, Bernard and Rouault, Isabelle. *L'Oeuvre Rouault Peint*. 2 vols. Monte Carlo: Éditions André Sauret, 1988.

Eglington, Laurie. "Braque, Matisse and Picasso Exhibited." *Art News* (March 17, 1934),1, 4-6.

Eglington, Laurie. "Paul Rosenberg, Now in New York, Comments on Art." *Art News* (December 2, 1933), 1, 4.

Flam, Jack D. *Matisse on Art*. London: Phaidon Press Limited, 1973.

Flint, Ralph. "New Housing for The Phillips Memorial Gallery." *Art News* (December 27, 1930), 3-4.

Foresta, Merry, et al. *Perpetual Motif: The Art of Man Ray*. New York: Abbeville Press, 1988.

Frankfurter, Alfred M. "Picasso in Retrospect: 1939-1900; The Comprehensive Exhibition in New York and Chicago." *Art News* (November 18, 1939), 11, 21, 26-28.

Gee, Malcolm. *Dealers, Critics and Collectors of Modern Painting: Aspects of the Parisian Art Market Between 1910 and 1930*. New York: Garland Publishing, Inc., 1981.

Gimpel, René. *Journal d'un collectionneur: marchand de tableaux*. Paris: Camann-Levy, 1963.

Gordon, Irene. *Four Americans in Paris*. New York: The Museum of Modern Art, 1970.

Green, Christopher. *Cubism and its Enemies: Modern Movements and Reaction in French Art, 1916-28*. London and New Haven: Yale University Press, 1987.

Grenier, Roger. *Brassaï*. Paris: Centre National de la Photographie, 1987.

Elderfield, John. *Matisse in the Collection of the Museum of Modern Art*. New York: Museum of Modern Art, 1978.

Heilbrun, Françoise and Néagu, Philippe. *Bonnard Photographer*. Paris: Éditions de la Réunion des Musées Nationaux, 1987.

Heilbrun, Françoise and Néagu, Philippe. *Portraits d'artistes*. Paris: Paris: Éditions de la Réunion des Musées Nationaux, 1986.

Hobhouse, Janet. *The Bride Stripped Bare: The Artist and the Female Nude in the Twentieth Century*. New York: Weidenfeld and Nicolson, 1988.

Hobhouse, Janet. "What did These Sensuous Images Really Mean to Matisse." *Connoisseur* (January 1987), 60-67.

Hobhouse, Janet. "Nudes; The Vision of Egon Schiele and Pierre Bonnard." *Connoisseur* (June 1984), 98-109.

Hope, Henry R. *Georges Braque*. New York: Museum of Modern Art, 1949.

Klüver, Billy and Martin, Julie. *Kiki's Paris: Artists and Lovers 1900-1930*. New York: Harry N. Abrams, 1989.

Leymarie, Jean. *Georges Braque*. New York: Solomon R. Guggenheim Museum, 1988.

Liberman, Alexander. *The Artist in His Studio*. New York: The Viking Press, 1960.

Marquis, Alice Goldfarb. *Alfred H. Barr, Jr.: Missionary for the Modern*. New York and Chicago: Contemporary Books, 1989.

McAlmon, Robert and Boyle, Kay. *Being Geniuses Together, 1920-1930*. San Francisco: North Point Press, 1984.

Millner, John. *The Studios of Paris; the Capital of Art in the Late Nineteenth Century*. New Haven and London: Yale University Press, 1988.

Newman, Sasha M., ed. *Bonnard: The Late Paintings*. Washington, D.C.: The Phillips Collection, 1984.

"Notes: The Phillips Memorial Gallery." *The American Magazine of Art* (March 1922), 95-96.

Philadelphia Museum of Art. *A. E. Gallatin Collection, "Museum of Living Art."* Philadelphia: Philadelphia Museum of Art, 1954.

Phillips, Marjorie. *Duncan Phillips and His Collection*, rev. ed. New York: W. W. Norton & Co., 1982.

Platt, Susan Noyes. *Responses to Art in New York in the 1920s*. Ph.D. Dissertation, The University of Texas at Austin, 1981.

Rathbone, Eliza E. *Duncan Phillips: Centennial Exhibition*. Washington, DC: The Phillips Collection, 1986.

Rubin, William, ed. *Pablo Picasso: A Retrospective*. New York: The Museum of Modern Art, 1980.

Rubin, William, et al. *Picasso in the Collection of the Museum of Modern Art*. New York: The Museum of Modern Art, 1972.

Russell, John. *G. Braque*. London: Phaidon Press Ltd., 1959.

Schneider, Pierre. *Matisse*. Trans. Michael Taylor and Bridget Strevens Romer. New York: Rizzoli, 1984.

Silver, Kenneth E. *Esprit de Corps: The Art of the Parisian Avant-Garde and the First World War, 1914-1925*. Princeton: Princeton University Press, 1989.

Silver, Kenneth and Golan, Romy. *The Circle of Montparnasse; Jewish Artists in Paris 1905-1945*. New York: Universe Books, 1985.

Soby, James Thrall. *Georges Rouault: Paintings and Prints*. New York: The Museum of Modern Art, 1945.

Stein, Gertrude. *The Autobiography of Alice B. Toklas*. New York: Vintage Books, 1933.

Tuchman, Maurice. *Chaim Soutine 1893-1943*. Los Angeles: Los Angeles County Museum of Art, 1968.

Turner, Elizabeth Hutton. *American Artists in Paris 1919-1929*. Ann Arbor and London: UMI Research Press, 1988.

Turner, Elizabeth Hutton. *Men of the Rebellion: The Eight and Their Associates at The Phillips Collection*. Washington, DC: The Phillips Collection, 1990.

Warren, Rosanna. "A Metaphysic of Painting: The Notes of André Derain." *The Georgia Review* (Spring 1978), 94-112.

Duncan Phillips's Writings

—— "At the Opposite Ends of Art." *The Yale Literary Magazine* 70 (June, 1905), 339-341.

—— "Corot" *The Yale Literary Magazine* 72 (November 1906), 54-58.

—— "The Impressionistic Point of View." *Art and Progress* 3 (March 1912), 505-11.

—— "Revolutions and Reactions in Painting." *The International Studio* 51 (December 1913), cxxiii-cxxix.

—— *The Enchantment of Art as Part of the Enchantment of Experience*. New York: John Lane Company, 1914.

—— "Fallacies of the New Dogmatism in Art, Part I." *The American Magazine of Art* 9 (December 1917), 43-48.

—— "Fallacies of the New Dogmatism in Art, Part II." *The American Magazine of Art* 9 (January 1918), 101-106.

—— "A Letter from Duncan Phillips." *The Arts* 7 (June 1925), 299-302.

—— *A Collection in the Making; A Survey of the Problems Involved in Collecting Pictures Together with Brief Estimates of the Painters in the Phillips Memorial Gallery*. New York: E. Weyhe, 1926. (Phillips Publications Number Five)

—— "Intimate Impressionists," Exhibition pamphlet. May 8-30, 1926. Washington, D.C.: The Phillips Memorial Gallery, 1926.

—— *The Enchantment of Art as Part of the Enchantment of Experience: Fifteen Years Later*, 2nd ed., rev. Washington, D.C.: Phillips Publications, 1927.

—— "Pierre Bonnard," in *A Bulletin of the Phillips Collection Containing Catalogue and Notes of Interpretation Relating to a Tri-Unit Exhibition of painting and Sculpture*, Exhibition, Phillips Memorial Gallery, February and March 1927.

—— "Art in Washington; The Phillips Memorial Gallery." *The Forerunner* 2 (Easter 1928), 18-24.

—— "Leaders of French Art Today; Exhibition of characteristic works by Matisse, Picasso, Braque, Segonzac, Bonnard, Vuillard, Derain, André, Maillol." Exhibition pamphlet. Phillips Memorial Gallery, December 3, 1927-January 31, 1928.

—— "A Survey of French Painting From Chardin to Derain." *A Bulletin of the Phillips Collection Containing Catalogue and Notes of Interpretations Relating to a Tri-Unit Exhibition of Paintings and Sculpture*. Exhibition, Phillips Memorial Gallery, February-May, 1928, 11-23.

—— "The Many Mindedness of Modern Painting." *Art and Understanding* 1 (November 1929), 50-72.

—— "The Palette Knife; A Collection Still in the Making." *Creative Art* 4 (May 1929), xiii-xxv.

—— "Free Lance Collecting." *Space* 1 (June 1930), 7-8.

—— "Modern Art, 1930." *Art and Understanding* 1 (March 1930), 131-144.

—— *The Artist Sees Differently; Essays Based Upon the Philosophy of a Collection in the Making*. 2 vols. New York: E. Weyhe, 1931.

—— "Modern Art and the Museum." *The American Magazine of Art* 22 (October 1931), 271-276.

—— "The Modern Argument in Art and its Answer." *A Bulletin of The Phillips Memorial Gallery Containing Notes of Interpretation Relating to Various Exhibition Units*, October 1931-January 1932, 37-73.

—— "Personality in Art; Reflections on Its Suppression and the Present Need for Its Fulfillment." *The American Magazine of Art* 28 (February, March, April, 1935), 78-84, 148-55, 214-20.

—— "The Functions of Color in Painting, An Educational Loan Exhibition," exhibition booklet. Washington, DC: Phillips Memorial Gallery, 1941.

—— [Georges Braque] "The Nation's Great Paintings; Georges Braque; Still Life with Grapes," The Twin Editions, New York, 1945.

—— "Pierre Bonnard." *The Kenyon Review* 11 (Autumn 1949), 561-66.